IMAGES
of America

LAKE ARROWHEAD

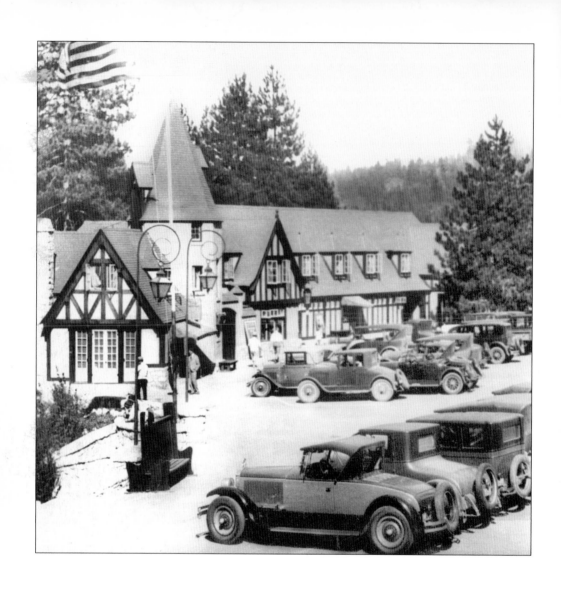

This book is dedicated to my loving husband, Douglas,
who makes me feel like we can accomplish anything together.
—Rhea-Frances Tetley

IMAGES
of America

LAKE
ARROWHEAD

Rhea-Frances Tetley

ARCADIA

Copyright © 2005 by Rhea-Frances Tetley
ISBN 0-7385-2918-4

Published by Arcadia Publishing
Charleston SC, Chicago IL, Portsmouth NH, San Francisco CA

Printed in Great Britain

Library of Congress Catalog Card Number: 2004108189

For all general information contact Arcadia Publishing at:
Telephone 843-853-2070
Fax 843-853-0044
E-mail sales@arcadiapublishing.com
For customer service and orders:
Toll-Free 1-888-313-2665

Visit us on the internet at http://www.arcadiapublishing.com

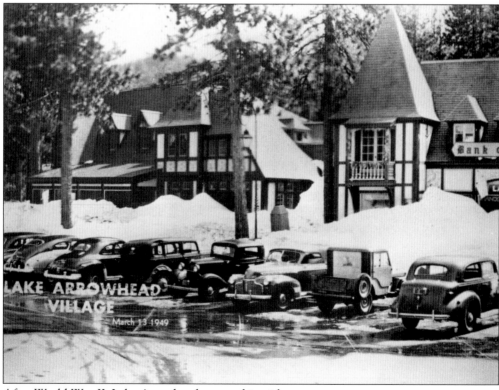

After World War II, Lake Arrowhead resumed its title as a top resort.

CONTENTS

ACKNOWLEDGMENTS

So many people have helped me not only in this project, but also in all aspects of my life before and during the creation of this book. I want to thank each of them, but it would take an entire book just to mention them all. I want each of you to know I appreciate your input and I thank you for your encouragement.

I want to thank my parents Ruth and Richard Tetley, grandparents, and great-grandparents, and great-aunt Frances Harthan for sharing with me the rich history of the San Bernardino Mountains and for choosing such a beautiful area to develop. I want to thank my husband of 31 years, Douglas Motley, for his encouragement and editorial attention to everything I write; my children David and Sean Motley for being their individual selves; and Katie and Amelia for adding to our family. I want to thank Dennis Labadie, publisher of the *Alpenhorn News*, for publishing my weekly ramblings on history and for the use of his photo scanners and computers. I want to thank my co-workers Kay Roberts, Christine Washburn, John Massie, and others in Redlands for listening to my never-ending discussions and comments on everything, including this book; your support has been essential.

I want to thank all the members of the Rim of the World Historical Society, especially President Larry Don Vito, W. Lee Cozad, Mary Barlow, Stan Bellamy, and Russ Keller, for their pictures and ideas. Don Foster, J. Putnam Henck, and Pauliena La Fuze, thank you for sharing your memories with me and others and for inspiring and encouraging me to write about the San Bernardino Mountains. Thank you, Tom Powell Jr., for inviting me to help start the Crest Forest Historical Society back in the 1980s. If not for you I would never have collected all these photos and stories. There are so many who have assisted me, and I apologize for not mentioning each of you by name, but I am grateful for your help and encouragement. Thank you.

—Rhea-Frances Tetley

Lake Arrowhead is located north of the city of San Bernadino in the mountains between the coastal plain and high deserts of Southern California.

6

INTRODUCTION

The history of Lake Arrowhead, California, parallels the history of Southern California during the last 200 years. Yet its isolated location, mountain geography, forest environment, and higher elevation than the surrounding landscape have created a completely different Southern California experience for those who moved there.

Lake Arrowhead has been a vacation destination since Native Americans arrived thousands of years ago to escape the hot summers in the Mojave Desert. The Indians lived most of their spring, summer, and autumn seasons in the San Bernardino Mountains, harvesting the natural acorns, pinion nuts, berries, and other foods, while hunting small animals in a peaceful setting.

When the Spanish arrived in the San Bernardino Valley with their large herds of cattle, the Indians of the mountains (Serrano) were little affected and continued their lifestyle. The ranchero owners rarely ventured into the mountains. After Don Antonio Lugo sold Ranchero San Bernardino to Mormon settlers, life began to change for the Indians.

The Mormons saw the trees along the crest of the mountains and, in 1851, built the first road into the mountains to harvest the timber. They built water and steam-powered sawmills and produced much of the lumber that built the fledgling towns of Los Angeles and San Francisco. The construction of the sawmills forced the Indians from their traditional hunting grounds.

The area was named "Little Bear Valley" because it was at a lower elevation than Big Bear. New roads were built into the mountains, including the Daley Canyon Road, which led directly into Little Bear Valley.

Water was an important issue in the dry California environment. The end of the 19th century saw many irrigation projects spring up in the state. A group of Cincinnati, Ohio businessmen were persuaded that a dam built in the Little Bear area would be a great investment, and the Arrowhead Reservoir Company was formed. The Arrowhead Reservoir project was 20 years into a massive seven-lake building project, intending to send water all over Southern California, when the Mojave Desert communities objected and sued. They won the argument that water from one watershed cannot be diverted to another and stopped the project. The Ohio group gladly sold the now "useless reservoir," with all their land holdings, to the Arrowhead Lake investment group, under the leadership of J.B. Van Nuys.

The group designed an upscale resort called Arrowhead Lake. A French Norman–style village was built on the shore, with all the modern 1920s conveniences, such as electricity and parking for automobiles, to appeal to Hollywood stars and other wealthy individuals. The name was changed to Lake Arrowhead.

Lake Arrowhead Village, and the lake itself, went through a succession of owners, including the Los Angeles Turf Club, who also built a hospital there. Boise Cascade Corp. sold the lake to the local property owners after the Sylmar Earthquake in the 1970s, when the State of California determined the earthen-filled dam was liable to fail during a similar earthquake event. The construction of Papoose Lake created equal pressure on both sides of the dam and supported the aging structure, saving Lake Arrowhead. It is now the central attraction for the summer season of activities such as water-skiing, boating, and fishing for the Arrowhead Lake Association property owners.

In 1980 the old decaying Lake Arrowhead Village was intentionally burned so a new village could be built. The new Lake Arrowhead Village is a two-story, multi-building complex with a wide variety of businesses, from groceries to banking for full-time residents, to resort businesses for the thousands of tourists who visit daily. The only building retained from the old village is the distinctive circular pavilion, where the orchestra played nightly during the previous 60 years.

The 21st century has brought new problems for the mountain resort area. A serious bark beetle infestation has killed millions of pine trees, and the largest fire in California's history, in October and November of 2003, threatened the area. The San Bernardino Mountain resort communities were spared total destruction from the flames by the dedication of firefighters from throughout the state, who fought hard to protect the homes and businesses of the thousands who are fortunate enough to call the area "home." Lake Arrowhead remains a year-round resort destination with nearby winter snow skiing and is as beautiful today as ever!

PHOTO CREDITS

A—From the *Alpenhorn News* photo files of Dennis Labadie, publisher
B—Photos from the historical files of Stan Bellamy
C—Photos from the Movie History Collection of W. Lee Cozad
H—Photos from J. Putnam Henck
K—From the photo collection of Russ Keller
L—From the Lake Arrowhead Village History files
R—From the photo files of the Rim of the World Historical Society
T—From the personal historical files of Rhea-Frances Tetley

I thank all of the above and the many generous people who donated photos to the Crest Forest Historical Society and the Rim of the World Historical Society throughout the years. I feel it is a privilege to be able to share these images.

One

INDIANS

THE FIRST MOUNTAIN VISITORS

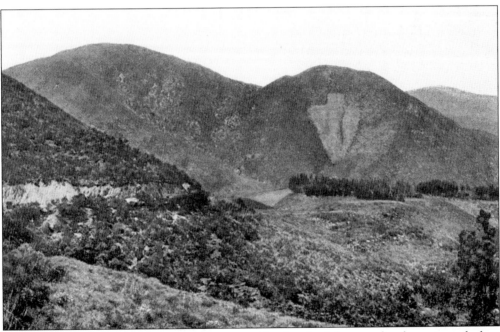

According to Cahuilla Indian legend, the natural landmark of the arrowhead was created when the Good Spirit led them to new hunting grounds by sending an arrow of fire across the heavens. The arrow landed and embedded itself in the hillside, pointing down at the warm mineral springs above the fertile San Bernardino Valley. This was the Great Spirit's sign that the hot springs were to be a peaceful location for all, and the valley below was given to them. This arrowhead scar on the mountainside has returned after numerous fires have burned the ground cover off of it because the terrain below the landmark is of a different composition than the surrounding area. It is this difference in soils and resulting ground cover that causes the arrowhead to be visible up to 30 miles away.

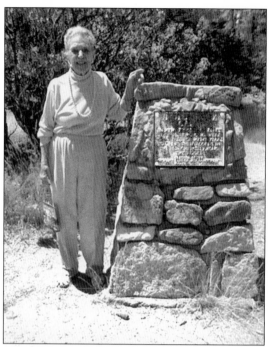

The Native Americans of the mountains referred to themselves as Yuhaviat, meaning "people of the pine tree place." The monument at Rock Camp, near Highway 173 on the 3W15 hiking trail, honors one of the sites where the nomadic tribe camped for over 500 years. Local historian Pauliena La Fuze has located, identified, and marked many significant places in the Lake Arrowhead area (T.)

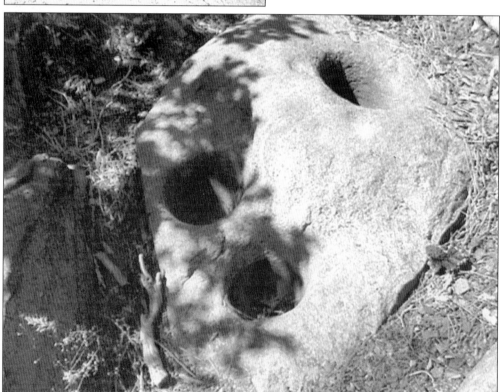

The women would gather and grind oak acorns and pinion nuts into a meal in the metates they made in the rock outcroppings adjacent to a meadow near Willow Creek. The women were skillful basket weavers. (T.)

The men of the village hunted with snares and bow and arrow. They gathered the firewood and made rope as well as their own tools. Village life was simple and spiritually based, as they believed everything in nature was interconnected. Rock Camp rests within this beautiful meadow. (T.)

The Yuhaviat, or Serrano, would sing songs while working. In their spare time, they told stories and played games. The pictographs they made on the rocks near the camp may have represented snakes or birds. (T.)

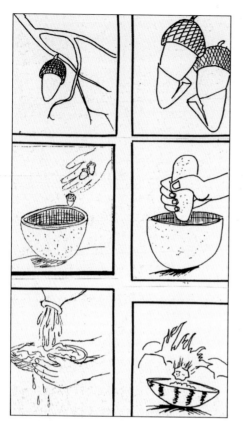

Processing acorns was a process involving many steps, beginning with the removal of the outer covering of the acorn, which was then ground into flour in a metate using a hand-held stone called a mano. The flour was leached with lots of boiling water to remove the bitter tannic acid. (T.)

Women cooked the meat meals over an open fire. Acorn flour was prepared by taking rocks heated in the fire and placing them into tar-coated baskets of water, heating the acorn meal into a mush. "Wi-wish" was made when the water was evaporated from the mush. Berries were added to sweeten the taste. (T.)

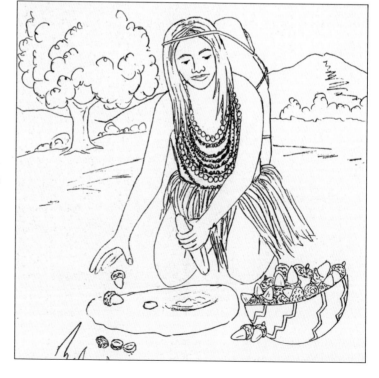

12

This Wi-wish was prepared by a forest ranger during a historical society tour of Rock Camp. It had a dried-out jelly consistency (it had been cooked in the sun) and tasted like gritty (acorn) flour. The bitterness of the acorns was softened with a natural berry sweetener. (T.)

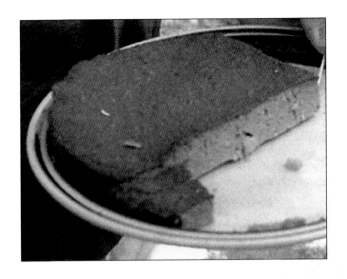

This 1995 photo shows Waterman Canyon's hot springs, which are located below the arrowhead, on the hillside. These springs, some of the hottest in the world, were created by friction produced by the San Andreas Fault. The Indians believed the hot springs were created by the Great Spirit and that they held magical and curative powers. (T.)

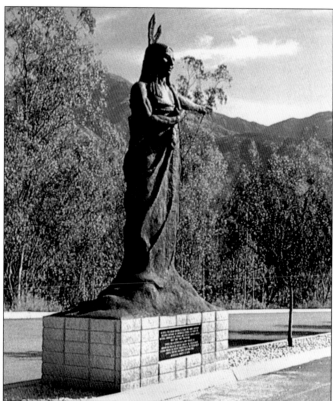

This statue located in Waterman Canyon points to the hot springs under the Arrowhead and honors the Indians who discovered them. When they fought, both sides would take their wounded to the sacred hot springs, as it was neutral ground. The bubbling mineral water was believed to contain curative spirits. (T.)

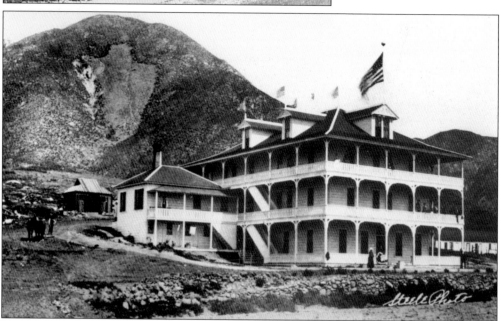

In 1863, David Noble Smith developed the eastern hot springs into a hygienic infirmary to treat "consumption, dropsy, and other incurable diseases," naming the area Arrowhead Springs. In 1883, Smith sold to the Arrowhead Hot Springs Company, who built the three-story hotel shown here. (R.)

California governor Robert W. Waterman (1887–1891) owned land and lived near the western hot springs until his death in 1891. Waterman's former ranch and undeveloped springs were then purchased by the Arrowhead Springs Hotel and developed and consolidated into their resort property. (R.)

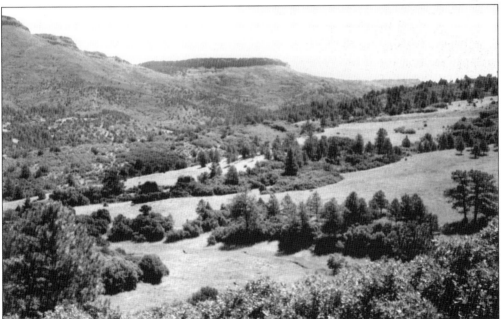

While he was still alive, Governor Waterman refused permission for anyone to build a road through his canyon. After his death, Waterman's Canyon became the main route for the Arrowhead Reservoir Company's toll road, which was constructed to bring material up the mountain for the building of Little Bear Dam. (T.)

The Arrowhead Reservoir Wagon Toll Road became known as Waterman Canyon Road after the county bought it in 1905. It was the access to Little Bear Lake and, in 1922, became the route to Lake Arrowhead Village. The lower canyon road was built alongside the picturesque creek. The creek flooded and washed out parts of the canyon road and damaged several bridges during the disastrous Christmas Day Flood of 2003, when 14 lives were lost. (R.)

Two

SAWMILLS AND
LUMBER DAYS

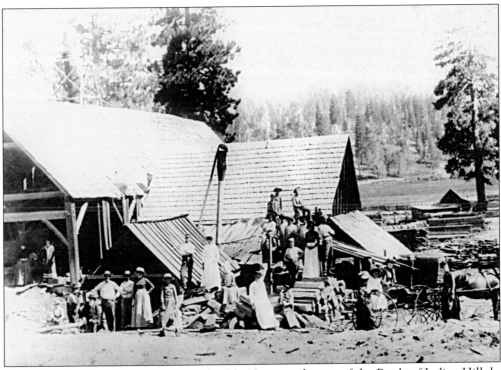

The Talmadge Sawmill, near present-day Blue Jay, was the site of the Battle of Indian Hill. In 1867 some renegade Paiute Indians attacked the sawmills, burning a mill down in Little Bear Valley. This is where the name "Burnt Mill" comes from. Francis Talmadge led a party of lumbermen who fought the 60 Paiutes on a ridge. After the Battle of Indian Hill, the Indians retreated to the desert and never returned to bother the sawmill owners again. (R.)

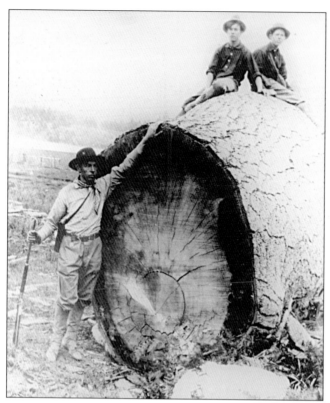

The virgin forest was quite enticing to the many small lumbering companies that entered the forest. As technology improved, more and larger trees could be cut and moved to the mills. (R.)

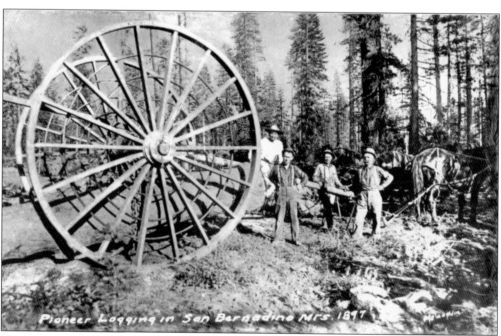

Horsepower was the driving energy behind logging in the 1890s. Horses hauled the logs to the mills and then pulled the wagons, loaded with the lumber, down the mountain, over the treacherously narrow and curvy lumber roads. (R.)

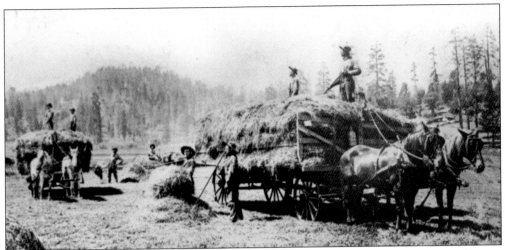

The Talmadge Mill raised hay on Little Bear Meadow to feed the work animals. Here they are loading the hay, which was grown on what is now the bottom of Lake Arrowhead. (R.)

This view of Little Bear Meadow shows the livestock and haystacks from the Talmadge Mill. The Talmadge family operated their sawmill on 320 acres of timber claims in the Little Bear area from the 1860s until a fire destroyed their mill in 1894. Francis Talmadge and sons then went to work doing lumbering for the Arrowhead Reservoir Company. (R.)

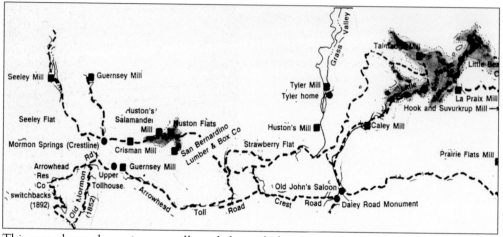

This map shows the major sawmills and the early logging roads located in the west end of the San Bernardino Mountains that operated from the 1860s to the 1910s. These mills produced much of the wood used to build the rapidly expanding towns of Los Angeles and San Francisco. (R.)

The Daley Canyon Toll Road was also known as the Twin and City Creek Turnpike. Edward Daley was the surveyor for the Mountain Turnpike Company, which designed the road in 1870 from Del Rosa, up the steep slopes between Strawberry and City Creeks, and over the crest into Little Bear Valley through present-day Agra Fria and Blue Jay. (R.)

The Daley Toll Road was the highest quality road into the mountains at the time. It was wider, not as steep as previous routes, and greatly facilitated the movement of lumber out of Little Bear Valley. Each mill was moving 4,000–6,000 board feet of lumber down the mountain, on the road, yearly. The 1880s were prosperous years for the lumber companies. (R.)

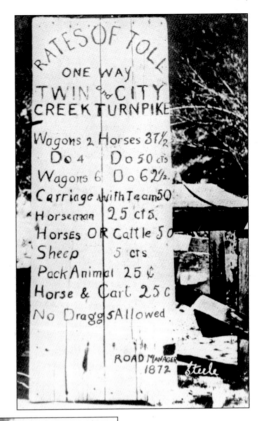

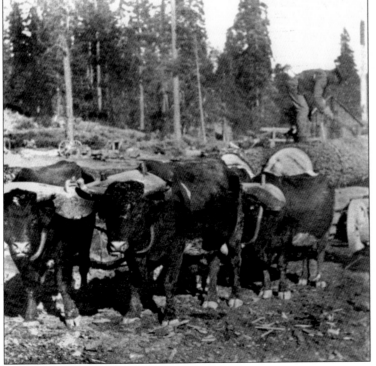

Early loggers used strong oxen to drag the logs to the sawmills. Some pulled the logs on the ground, but most used solid-wheeled carts or large-wheeled wagons. Oxen were good workers on level ground but were not as efficient on the steep hillsides. (R.)

TREE SIGNATURES

Sugar Pine
175 - 200 feet tall
Needles in bunches of 5
Pinecones: 16 inches long

Jeffrey Pine
Smells like vanilla
Needles in bunches of 3
Needles stay on tree for 6 - 9 years

Incense Cedar
100 - 150 feet tall
Soft, fibrous bark
Flat branch-lets are covered with green scales

Most loggers were cutting Sugar Pine, Ponderosa, and Jeffrey Pine for building purposes. The cedar was used for roofing shingles. It is said the San Bernardino National Forest supplied most of the wood that built the houses in Los Angeles, Riverside, and San Bernardino Counties. (R.)

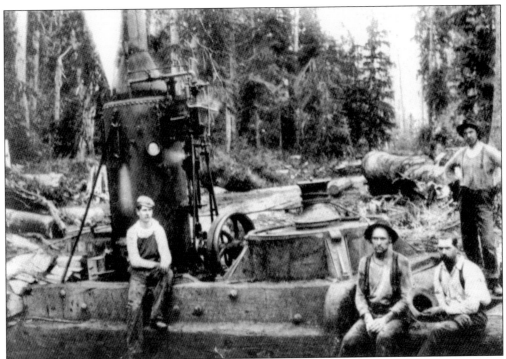

The Dolbeer Donkey Steam Engine was one of the methods used to drag logs to the sawmill. The steam engine was placed on a wooden-skid frame. By stringing cable around standing trees, the winch would drag the sledded engine and logs over the rugged terrain and up steep hillsides to the mill. (R.)

The first Grass Valley Sawmill of Charles and his brother Joseph Tyler, with members of their families, is shown in this picture. The mill operated from 1872 to 1891. A second mill was built after the Arrowhead Reservoir Company bought this mill and land. (R.)

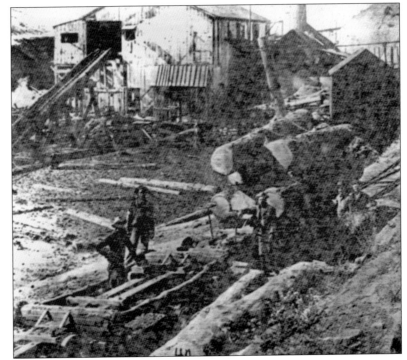

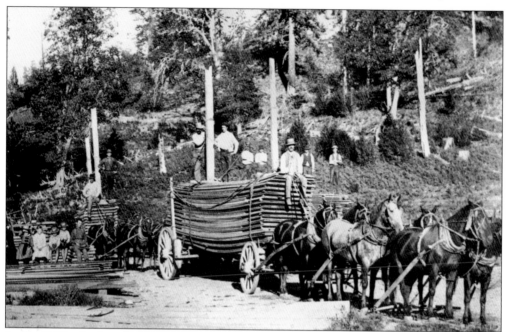

In the 1870s, the Joseph B. Tyler Sawmill was operating in Little Bear Valley, sending lumber down to the San Bernardino Valley by way of the new Daley Canyon Road. This picture was taken in 1872 in Grass Valley, near the location of the current golf course. (R.)

The early trees were all cut by hand, as chainsaws and cranes were not yet invented. When the Arrowhead Reservoir Company came to Little Bear Valley to build a dam, they purchased the sawmills and lands of the local loggers, such as the Tylers, Talmadges, John Hook, John Suverkrup, and Peter Guernsey. They then hired those men to work in the sawmills, as the dam construction needed lots of timber. (R.)

Three

BUILDING LAKE ARROWHEAD

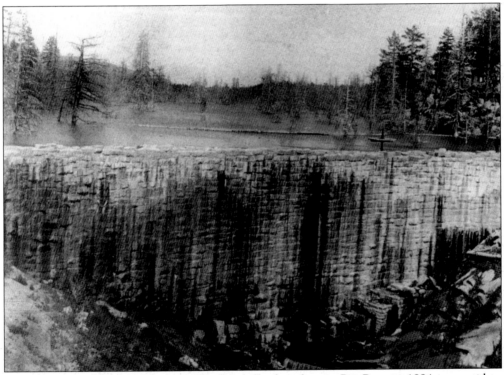

Frank Brown and Hiram Barton, of Redlands, built a dam in Big Bear in 1884 to provide a constant supply of water to their town and citrus groves. This inspired the formation of the Arrowhead Reservoir Company to supply water to the San Bernardino Valley. In 1891 three Ohio businessmen invested in building an irrigation system with water from the San Bernardino Mountains. They planned to build a three-lake system to bring water to the San Bernardino Valley by capturing the flow from three watershed areas and diverting them from the desert towards the north, to the valley south of the mountain chain. (R.)

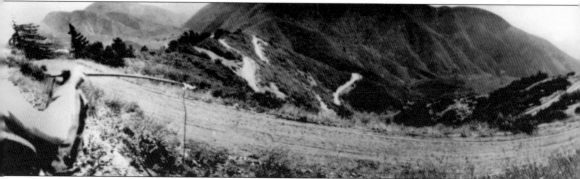

After Governor Waterman's death, The Arrowhead Reservoir Company purchased the old abandoned lumber road, built by Mormon loggers in 1851, through Waterman Canyon to the mountains. It was widened and re-graded, adding 13 switchbacks to lessen the steep grade during the upper three miles, to bring supplies to the Little Bear Valley site in order to build a dam there. (R.)

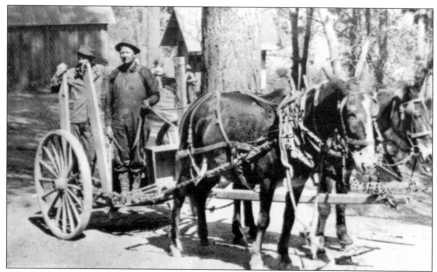

The wagons had to stop and rest the horses every hour when transporting the heavy loads to the summit.

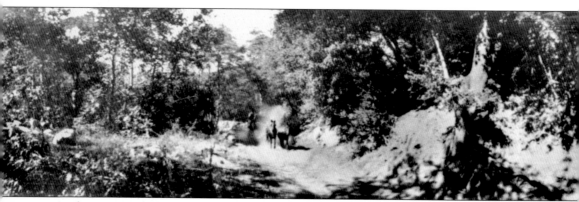

At the crest, after the steep face of the mountain had been climbed, the 16-horse teams were rested and new 8-horse teams were used to move the same load over to Little Bear Valley, as the grade was less severe across the mountaintop. (R.)

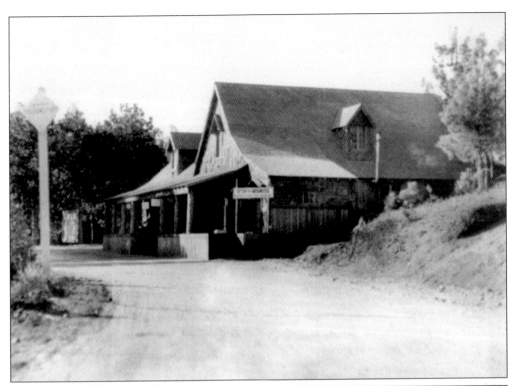

The Arrowhead Reservoir Company built a warehouse at the crest of the mountain, where the horses and men rested after the 16-hour trips up to the summit. This resting area, which had corrals, a camp for the drivers, and the warehouse, was eventually developed into the town of Crestline. (R.)

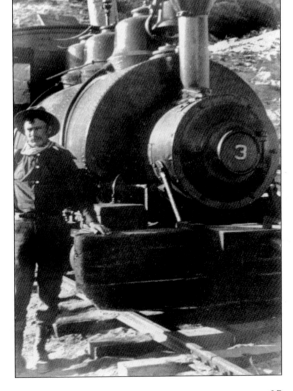

Tons of equipment, including 2 narrow-gauge locomotives, 45 dump cars, steam shovels, and hundreds of thousands of bags of dry cement (for the cement core of the dam) were hauled, by animal power, up the Arrowhead Reservoir Toll Road, through Waterman Canyon. (K.)

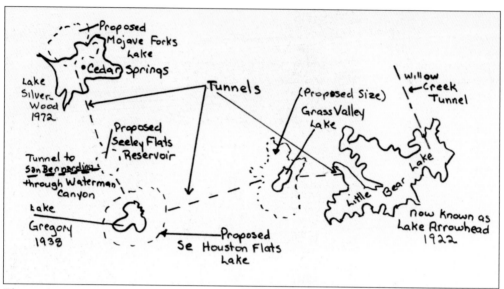

The Little Bear Lake Project was designed to have three lakes. One would be in Huston Flat, one in Grass Valley, and one in Little Bear Valley. Tunnels were planned to connect the lakes and redirect the flow of the water towards the San Bernardino Valley so 120,000 acres of fields could be irrigated. (T.)

San Bernardino City Engineer A.H. Koebig, after much research, decided that Little Bear Valley was a good location for a dam to divert the water needed for San Bernardino Valley agricultural needs. Koebig traveled east to Ohio to convince James Gamble (of the Proctor and Gamble Soap Company) and friends of this great investment. The Arrowhead Reservoir Company was formed. (R.)

To speed delivery of cement for the dam's core, an incline cable system was built from Waterman Canyon to Skyland, east of the warehouse, on the crest. It was designed, engineered, and prefabricated off-site for quick installation. (R.)

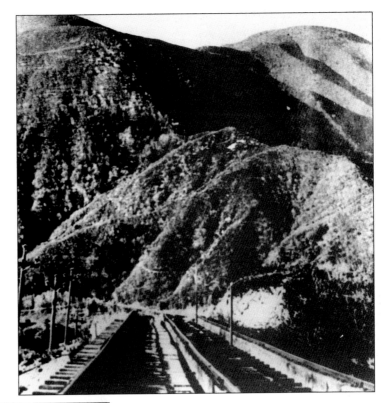

An untimely rainstorm washed out the pre-graded rail bed; however, the installers put the rails down anyway, resulting in a dip in the rails when completed. It never worked correctly, and the "Incline Railroad" was soon abandoned. (R.)

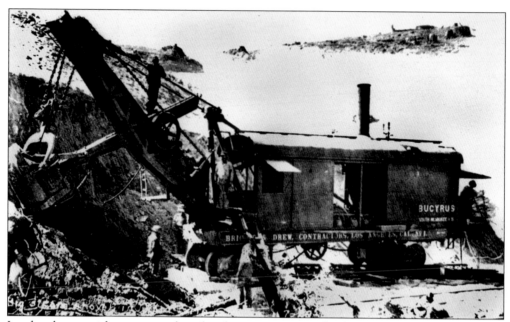

Land and water rights were purchased and construction on the dam began in 1893. The three-lake plan was expanded to seven, with 60 miles of tunnels connecting them, to bring even more irrigation water to the San Bernardino Valley and beyond. (R.)

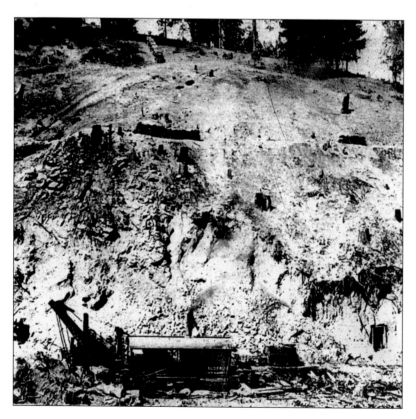

Little Bear Dam was built in the semi-hydraulic style, with a steel-reinforced cement core and earthen walls. It was to be 200 feet tall, 720 feet long, and 1,100 feet wide at the base. (R.)

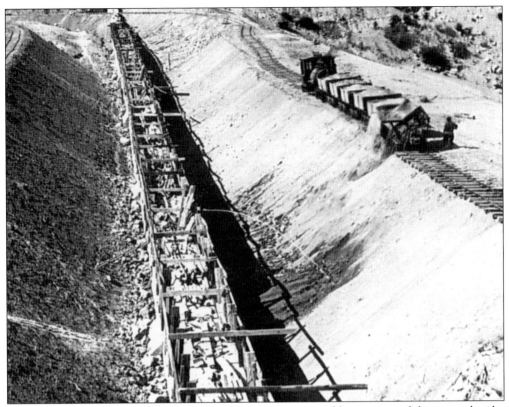

The central cement core of the Little Bear Dam was supported by compacted dirt on each side of it.

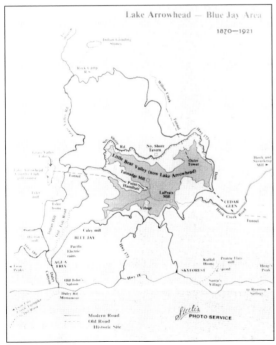

The tunnels were immediately dug to connect the future lakes and to move the water between them. The nine-foot diameter Hook Creek Tunnel, which empties into Emerald Bay, is 3,300 feet in length. The tunnels were much more difficult than expected to dig, and only three tunnels were ever completed. (R.)

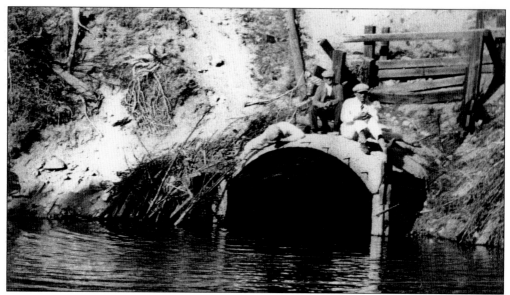

Two other tunnels were built. The 10,000-foot-long Willow Creek Tunnel, which connects the Outlet Tower to Willow Creek, can be seen today jutting out of the lake. The 4,172-foot-long Grass Valley Tunnel, which connects from Meadow Bay, created Grass Valley Lake, next to the current golf course. The first tunnel was completed in 1894. Several tunnels were started and never completed. (K.)

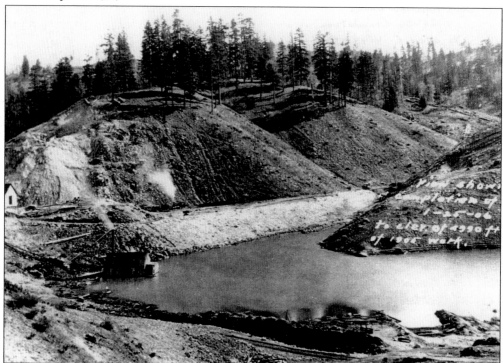

The work on the dam for Little Bear Valley began in 1904, as all the logs were cleared and Little Bear Creek was diverted. The steam engines were used to move the dirt, and they would dump it along the cement core. (K.)

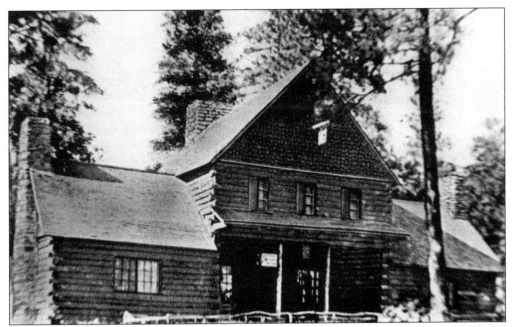

The Arrowhead Mountain Club's members were the area's rich and influential and included J.E. Mooney, general manager of the Arrowhead Reservoir Company. Their private summertime resort was called The Squirrel Inn, after a book written by Frank Stockton. (R.)

The Arrowhead Mountain Club's members were conservative conservationists. The document creating the San Bernardino Forest Preserve was displayed in their lodge building. Squirrel Inn members Sam Halsted, J Harrison Wright, Arthur Halsted, and Hutchie Colson are shown here on a 1909 fishing exhibition to Deep Creek. (R.)

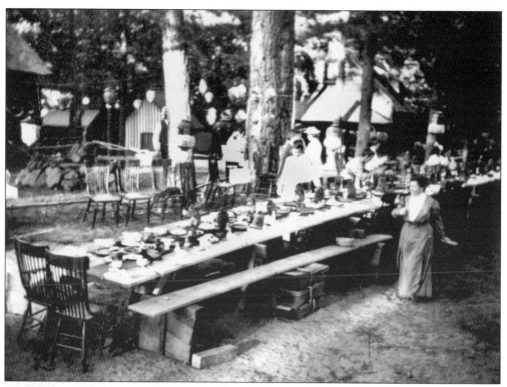

The annual Changing of the Squirrel Dinner was held on the third Saturday in August. The stuffed squirrel on their sign was retired and replaced with a new one. The retired squirrel was put in a place of honor, on the mantle. (R.)

The Squirrel Inn hosted John Muir and Teddy Roosevelt when they came to visit the San Bernardino Forest area. The San Bernardino Forest Preserve (now known as the San Bernardino National Forest) was created in part due to the lobbying efforts of the members of the Squirrel Inn. (R.)

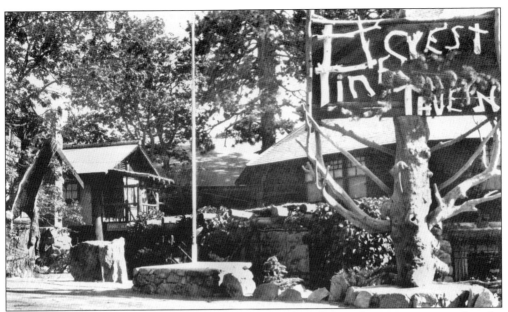

Dr. John Baylis, a member of the Squirrel Inn, purchased the adjoining property when he learned it was to be logged. He built the Pinecrest Resort so the public could escape the summer heat of the valley and enjoy the mountains. (R.)

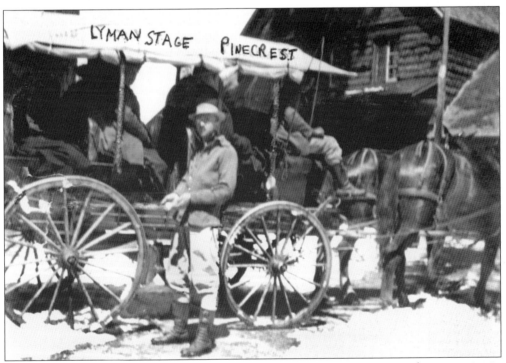

Before automobiles were allowed on the toll roads, most vacationers came to the mountains in horse-drawn stages. These stages took vacationers to the Skyland Inn (near the upper terminus of the abandoned Incline), Thousand Pines Camp, Pinecrest Resort, and the future Little Bear Lake area. (R.)

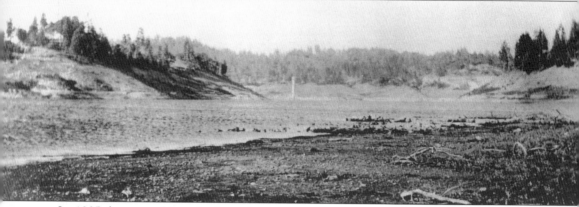

In 1905, because of lawsuits from desert property owners, more water rights and land were purchased and the irrigation project was refinanced at $6 million. The name Arrowhead Reservoir and Power Company reflected the decision for the dam to generate electricity. The outlet tower was completed in 1907. (K.)

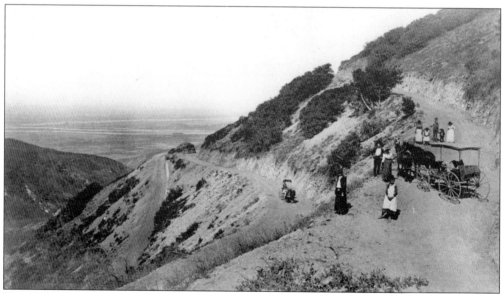

In 1905, San Bernardino County purchased the mountain toll roads, opening them to free public use, doubling the volume of visitors to the mountains. They used stages, wagons, and horses to get to the cooler air of the mountain areas. In 1909, autos were allowed on the dirt roads for the first time. (R.)

This 1908 picture shows the completed 184-foot-tall outlet tower for the lake. The outlet allowed water to flow into the Willow Creek Tunnel. The first time water was allowed to collect behind the 90-foot-tall dam it leaked and the water had to be released. (K.)

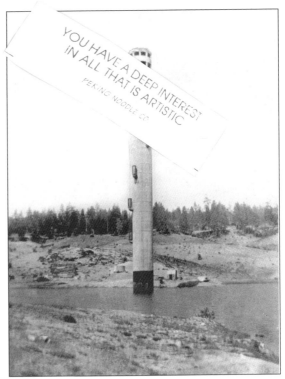

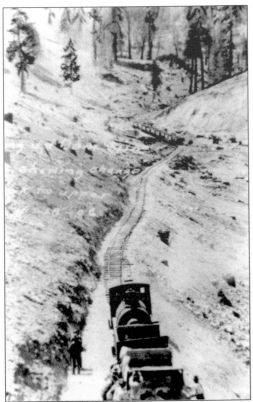

By 1912, the Little Bear Lake Dam was 80 percent completed, however only 6.5 miles of the planned 60 miles of tunnels were dug. The state favored the desert landowners in their lawsuits, thereby refusing to allow the Arrowhead Company to divert the natural flow of water for agricultural purposes. This eliminated the need to finish any more tunnels, or invest any more money in this project. (R.)

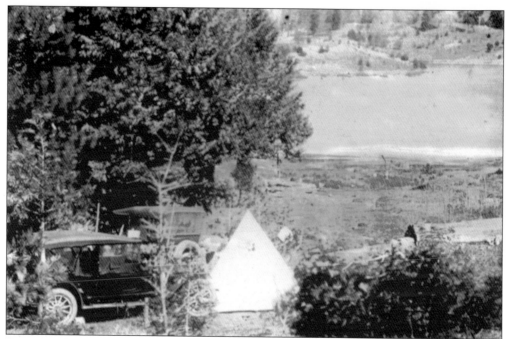

By 1913, the leaking core of the dam was repaired and its hydroelectric generators were working. The reservoir was filling and fishing was excellent. Camping and fishing became popular activities along the new lakeshore. (R.)

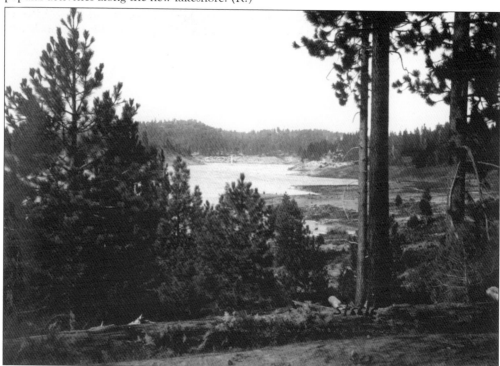

The lake was allowed to fill from natural runoff of the snows and rains from the local drainage areas. This 1913 photo shows the lake filling amid the beauty of the forest environment. (R.)

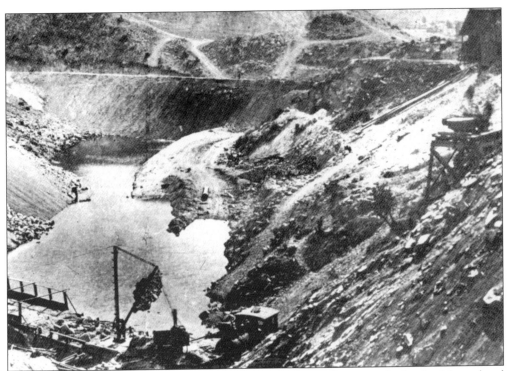

The multi-lake project was totally abandoned in 1912, due to the untimely death of Arrowhead Reservoir and Power Company General Manager James Edgar Mooney and the 1913 court decision. Mooney, who was a bachelor, had invested over $1 million of his own funds into the project. (R.)

This campsite is at the same location where Lake Arrowhead Village stands today. (Jean Jensen.)

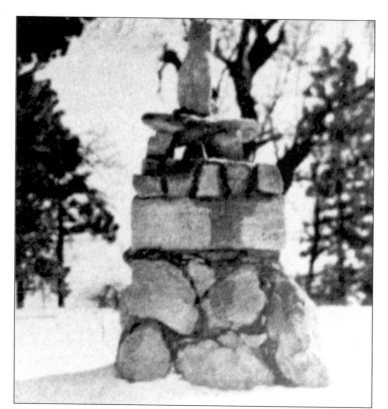

In 1915, the scenic, 101-mile, Rim of the World Road was completed due to the dedicated public relations efforts of Dr. John Baylis, of Pinecrest Resort. This is the marker, which still stands (although the top has fallen off) just west of Rim Forest. (T.)

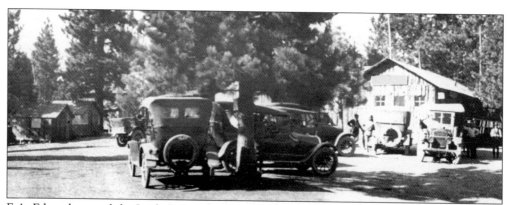

F.A. Edwards owned the Little Bear Lake Hotel and opened the Little Bear Lake Post Office in the same building on February 16, 1917. On the left are some of the cabins, and the post office, hotel office, and store are on the right.. (R.)

By 1919, Little Bear Lake had a 150-bed hotel, 26 rental cabins, a dance pavilion, a lunchroom, and 5 miles of the lake's shore were open for fishing. (K.)

Little Bear Lake became one of the most popular fishing resorts in Southern California. (T.)

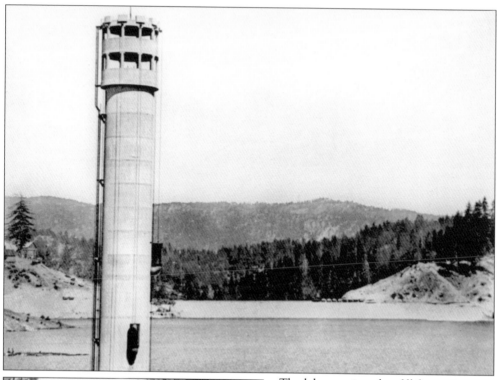

The lake continued to fill from winter storms. The outlet tower leads to the Willow Creek Tunnel, one of the few completed tunnels in the planned seven-lake project. The failed irrigation project, which had now become a popular fishing resort, was sold by the Arrowhead Reservoir and Power Company. (R.)

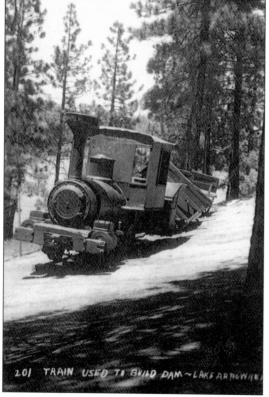

201 TRAIN USED TO BUILD DAM ~ LAKE ARROWHE

Little Bear Lake Village, as well as the hotel and cabins, were all bulldozed by the lake's new owner, The Arrowhead Lake Company. The A.L.C. wanted to eliminate public fishing and make the lake totally private, as they had plans for a luxurious private resort. They left few reminders of the old fishing village. (R.)

Four
LAKE ARROWHEAD
VILLAGE

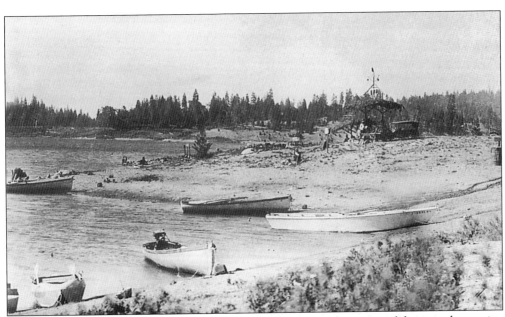

In 1920, Little Bear Valley was one of the most successful summer fishing and camping destinations in the San Bernardino Mountains. The lake had been stocked by the state fish hatchery for five years. Little Bear Lake had boat rental docks and five miles of shoreline open for shore fishing. The lake and surrounding areas were purchased in 1921 by the Arrowhead Lake Company, a Los Angeles syndicate whose plans did not include allowing the public to continue to use the lake. (T.)

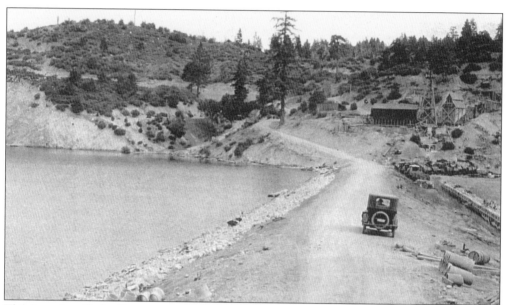

The Arrowhead Lake Company spent the first two years tearing down the buildings of the Little Bear Fishing Resort, finishing the dam, and building a road around the lake. They renamed the area Arrowhead Lake, after the arrowhead scar on the mountainside at the base of the mountain. (R.)

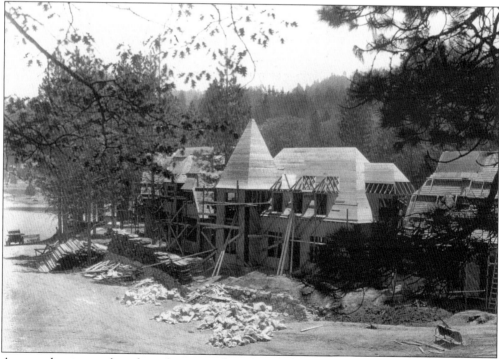

An upscale resort and residential area was designed. A French-Norman, English-themed village was built to provide the necessary amenities. The early 1920s were the years of "horse power," as shown by the graders, which were pulled behind horses and used before bulldozers with front blades were invented. (R.)

44

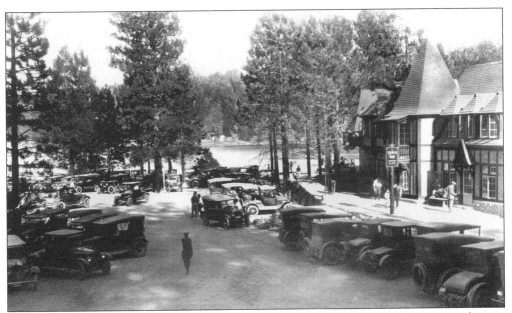

The new 1922 Arrowhead Lake Village included a dance pavilion, outdoor movie theater, restaurants, stores, and a beach with bath houses. (R.)

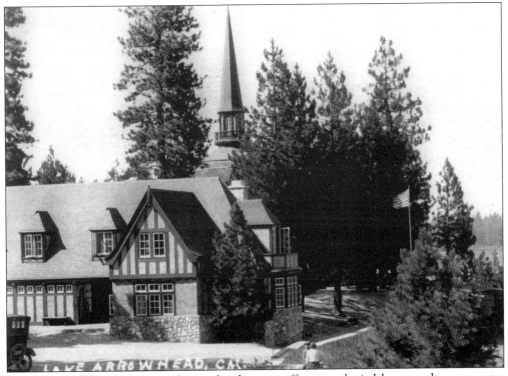

The "Arrowhead Lake" name chosen for the post office was denied because the postmaster general believed the mail would get confused with Arrowhead Springs, at the base of the mountain, so the company renamed the new resort "Lake Arrowhead." (R.)

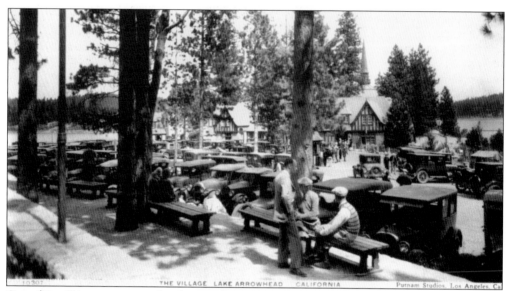

Over $8 million was spent developing the private lake into the most upscale resort on the mountain, with electricity available for buildings, parking for automobiles, and all the modern conveniences of the day. The village officially opened on June 24, 1922. (R.)

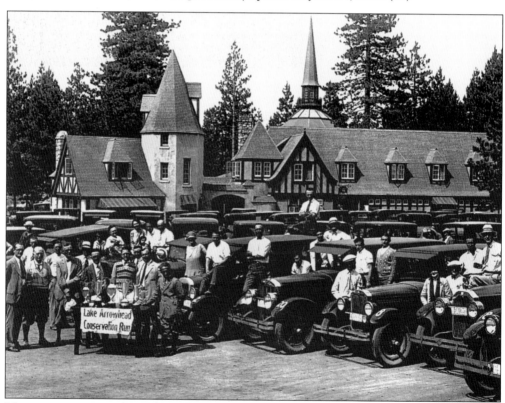

Many activities were planned at Lake Arrowhead Village to encourage tourists and give "down the hill" people an excuse to travel up the mountain roads. As the roads improved, the number of visitors to the area increased. (R.)

The completed 200-foot-tall dam generated electricity, which powered the pumps that brought the water from deep below the surface of the lake and piped it to all the subdivision lots and village structures. (J & K Fulton.)

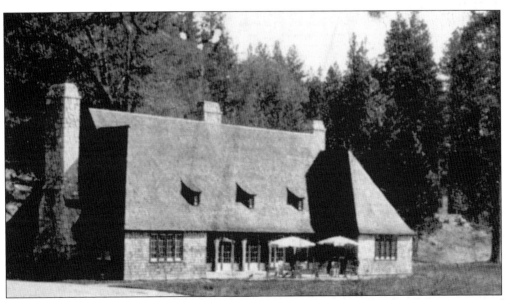

The North Shore Tavern, located across the lake from Lake Arrowhead Village, was one of three hotels built. It offered sailboats, tennis courts, stables, and excellent accommodations. Today it is known as the UCLA Conference Center. (R.)

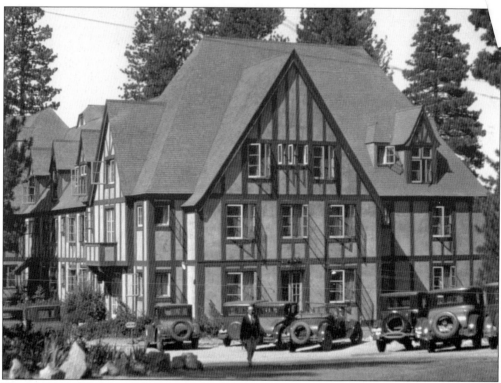

The luxurious lakefront Arlington Lodge, which opened in 1923, was approximately where the Lake Arrowhead Resort is now located, next to the village. It was later renamed the Lake Arrowhead Lodge. (T.)

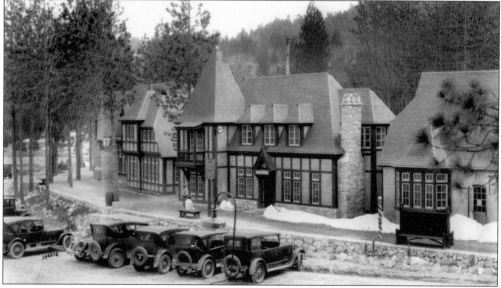

Lake Arrowhead Village was an immediate success. The Arrowhead Lake Company conducted a publicity campaign to promote the area, using postcards, newspapers, and magazines. The excellent economy of the 1920s, with the popularity of the automobile and the year-round pleasant weather of the area, made Lake Arrowhead a popular vacation destination. (R.)

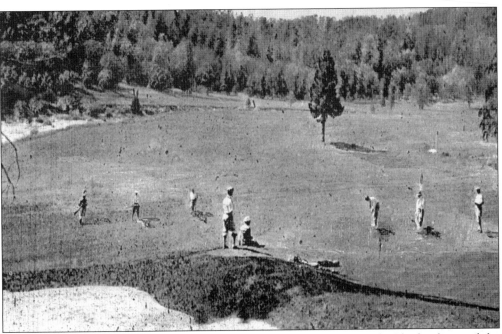

Amenities for the resort included a nine-hole golf course and paved roads. The land around the lake, called Arrowhead Woods, was subdivided for private homes and secluded north shore estates. (R.)

Deeds restricted homes from being visible from the lake. Other building restrictions included the style and size of buildings and prohibition of the excessive removal of trees. (T.)

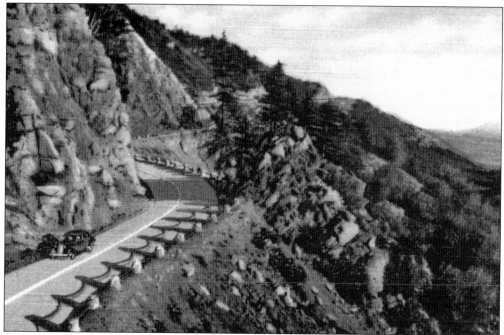

From 1928 to 1930, the Rim of the World Road, from San Bernardino, was re-graded, straightened, and paved for automobile use, making access to the Lake Arrowhead area much easier. (T.)

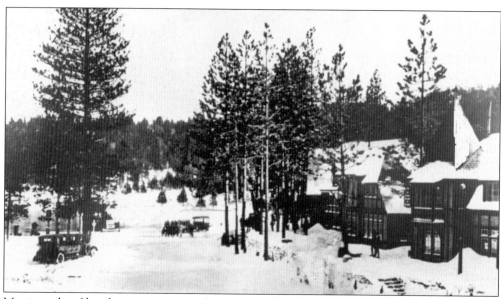

Movie studios filmed many movies in the area and the stars stayed in Lake Arrowhead's hotels. Many then purchased property in the area and built homes near the resort. The $8 million invested in the resort and development seemed to be paying off, as the image they created attracted the rich and famous. (R.)

At night, the Lake Arrowhead Orchestra played in the dance pavilion (the round building with the spire). Years later, famous bands, including Ozzie Nelson's, entertained the locals and visitors in the pavilion at Lake Arrowhead Village. (R.)

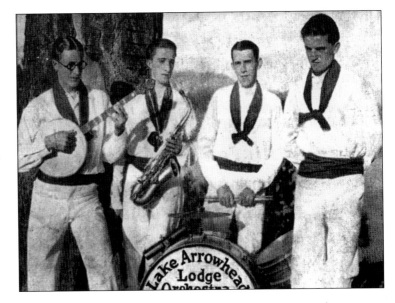

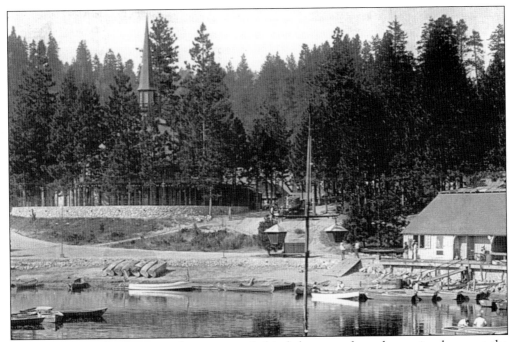

Pictured here is the dance pavilion, as seen behind the trees, from the peninsula across the village dock and lake area. (R.)

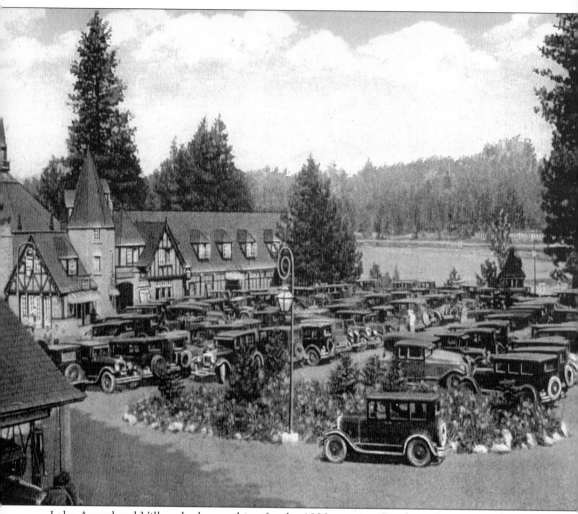

Lake Arrowhead Village had everything for the 1920s tourist. Gasoline, shopping, movie stars at the restaurants and hotels, golf, skiing and sledding in the winter, and wonderful summer water sports were all less than 90 miles from Los Angeles! (R.)

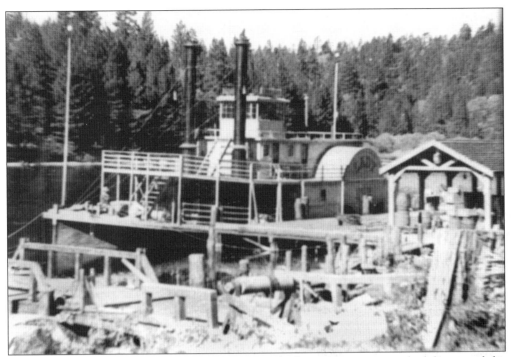

The 1930s were the Depression years, but fortunately the movie companies had discovered the mountains during the silent-film era, and they used Lake Arrowhead as a stand-in location for Europe, the Alps, and Canada. Lake Arrowhead was close to Hollywood and had three hotels appropriate for movie stars. This riverboat was used in *The Yearling*. (T.)

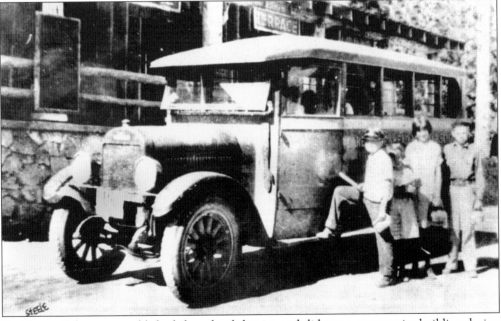

Residents of the area established the school district and did some community building during the 1930s, when real-estate sales slowed significantly. These kids are boarding the Lake Arrowhead school bus in front of the (current) Antlers Inn Restaurant in Twin Peaks. (R.)

During World War II, the Lake Arrowhead area served as a major rest and recreation destination for members of the armed forces. Years later, many former servicemen returned and brought their families to enjoy beautiful Lake Arrowhead and its village. (T.)

By 1941, the resulting effects of the Depression, combined with World War II, slowed the growth of the area to a virtual standstill. In 1946, the Lake Arrowhead Company went into receivership. The Los Angeles Turf Club, owners of Santa Anita Race track, purchased the lake and village and all of ALC's assets for only $2 million. (R.)

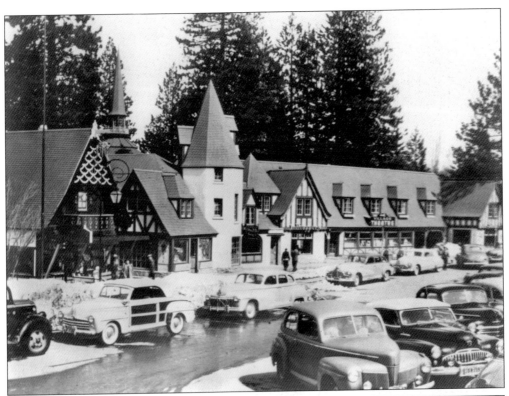

The Turf Club spent millions in the post-war years promoting the beauty, luxurious accommodations, and resort-like atmosphere of Lake Arrowhead. This photo is from 1946. (T.)

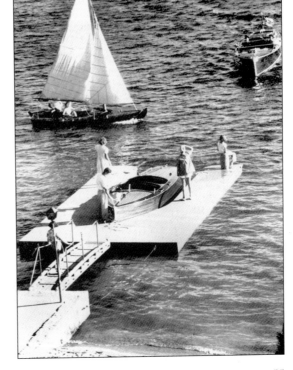

The Turf Club promoted events and activities for all four seasons, including sail-boating, sunbathing, shopping, and winter sports such as skiing, tobogganing, and ice-skating. This shot is from a full-color, six-page spread on Lake Arrowhead in *California Pathways* Magazine. (T.)

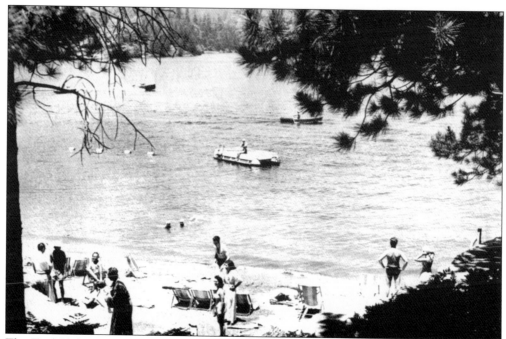

The Turf Club proved to be generous benefactors to the community. They donated land and funds for a hospital, a school, and then the former school building was given to the fire district. They added buildings to the village and new businesses were opened during the 1950s economic boom. (T.)

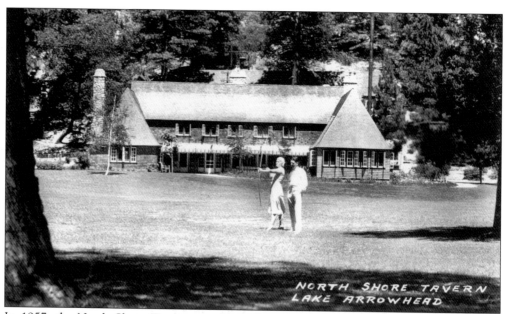

In 1957, the North Shore Tavern was donated to the State of California and became the nucleus for the UCLA Conference Center. (R.)

In 1960, a new Lake Arrowhead Development Company (LADCO), headed by Jules Berman, purchased the 800-acre Lake Arrowhead, the village, and the 3,200 surrounding acres from the Turf Club. LADCO set about developing the real property around the Lake, including the installation of sewers. (T.)

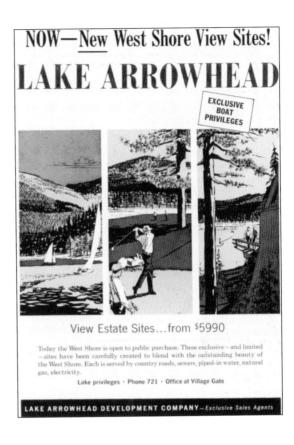

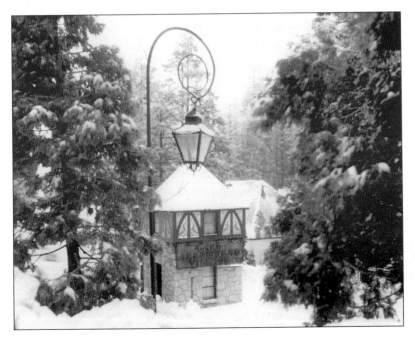

LADCO subdivided many new sections of lakefront property. The village (shown) was a popular year-round destination in the 1960s.

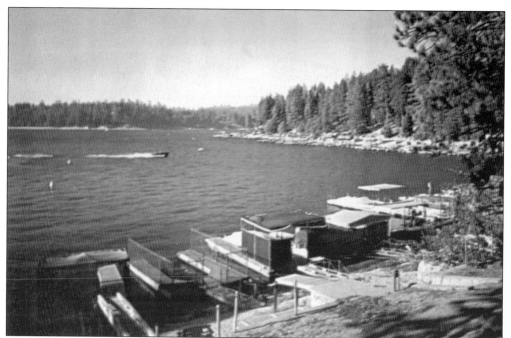

In 1967, Boise Cascade Corp. bought out LADCO and continued to subdivide the land around Lake Arrowhead, adding more lots and homes along the northern shore. Point Hamiltair Ranch and Movie Point were sliced into lots for mansions. This picture shows the docks around the lakeshore. (T.)

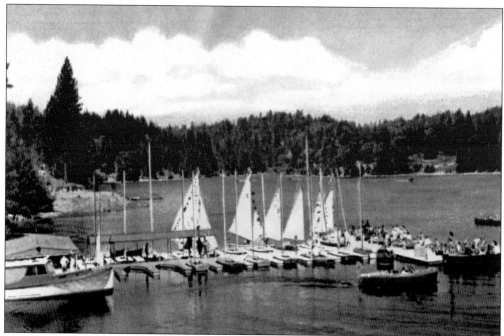

The Lake Arrowhead Yacht Club's sailboat races are one of the most popular uses of the lake during the spring to fall season. Water-skiing is also very popular with residents who have lake rights, which are acquired by owning property in Arrowhead Woods. (T.)

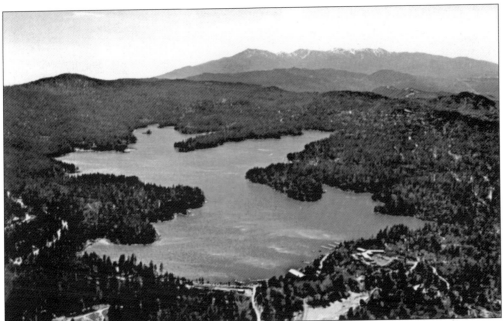

After the 1971 Northridge Earthquake, the state examined all earth-filled dams in California and determined that Lake Arrowhead's dam could fail during a large quake. They said that Lake Arrowhead must be drained or the dam reinforced. Boise Cascade did not want to invest the dollars needed. The dam is in the lower center of the picture, with the hospital on the ridge above it to the right. (T.)

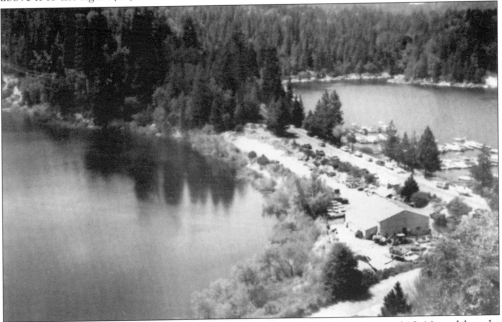

The property owners formed the nonprofit Arrowhead Lake Association (ALA) and bought Lake Arrowhead. They passed a bond and built another dam, downstream from the original dam, creating Papoose Lake in 1976. With equal water pressure on both sides of the dam, the lake did not have to be drained. (T.)

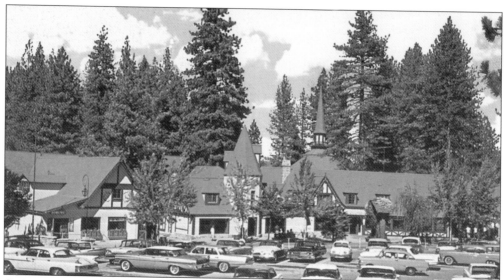

George Coult Properties purchased the village and lodge properties in 1978 and made plans to build a new village and hotel complex. This meant the original 1920s village had to be destroyed, which brought an outcry from local citizens. (T.)

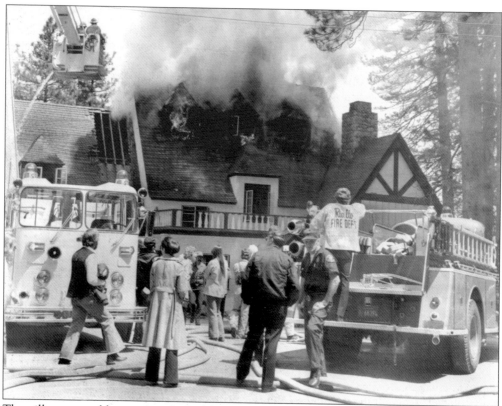

The village was sold very cheaply, building by building, to numerous Southern California fire departments. They conducted "Burn to Learn" exercises, analyzing how a building might burn, then igniting it and fighting the fire and performing post-fire analysis. (R.)

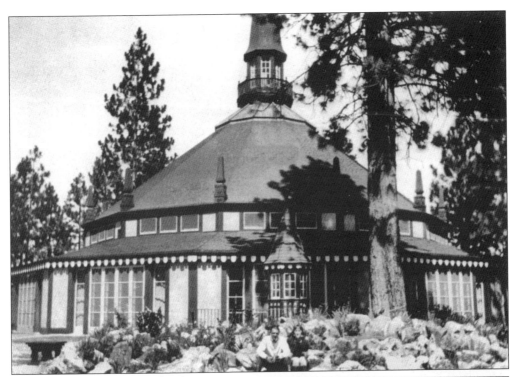

All buildings in Lake Arrowhead Village were razed, except for the original dance pavilion, one of the most distinctive buildings in the former village. (R.)

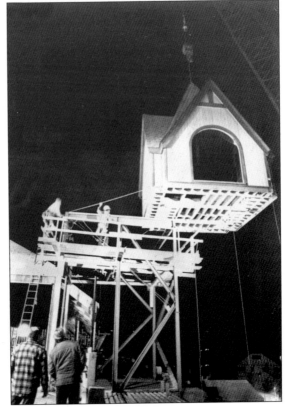

The new village was designed as a two-story complex, maintaining the alpine theme. The clock tower was hoisted by crane to its location, towering over the new Lake Arrowhead Village. (T.)

The new hotel was built by Hilton and had its grand opening in 1982 as the Arrowhead Hilton Lodge. Celebrities Bob Hope, former President Gerald Ford, and Baron Hilton attended the $500 a plate gala. (T.)

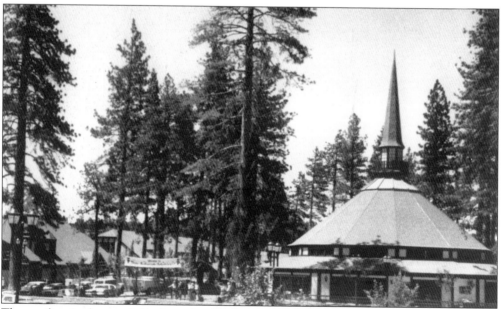

The pavilion in the new Lake Arrowhead Village is located in an area elevated above the lower parking lot. Its distinctive shape and unique history maintains a connection with Lake Arrowhead Village's past. (R.)

Five

RIM OF THE WORLD HIGHWAY

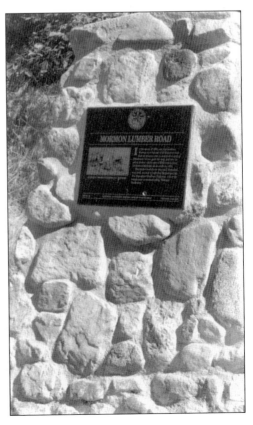

In 1852, the first road into the San Bernardino Mountains was the Mormon Lumber Road, built through what is now known as Waterman Canyon to bring logs down to construct a stockade to protect the new Mormon settlement we now know as San Bernardino from attack by the Indians. This steep road (46 percent grade) was abandoned after new lesser grade roads were cut into the mountains. It has been honored by two monuments, one in 1932 placed by the Thursday Club and this newer monument placed by the Sons of Utah in 1991 at the turnout below Crestline, where the Mormon Road crosses what is now State Highway 18. (T.)

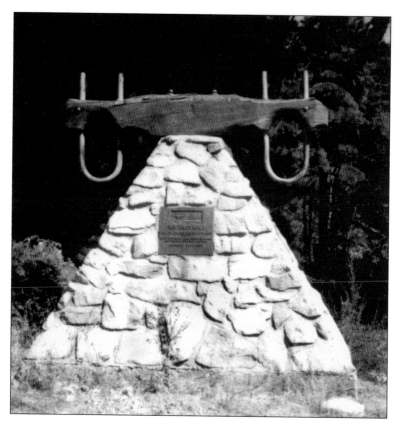

The Daley Lumber Road was built in 1870 as a direct route from Del Rosa to the Little Bear Valley area. The Talmadge Lumber Mill, located in Little Bear Valley, used the Daley Road to move lumber to the valley below. (T.)

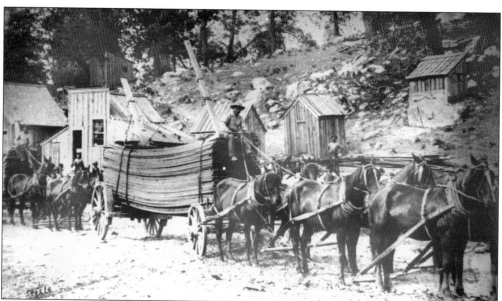

The logging toll roads were the only routes into the mountains and were owned by the logging or construction companies that built them. Each company set their own price for travel over its road. It was dangerous to confront a heavily loaded, downhill logging wagon on the narrow 14-foot wide roads. (R.)

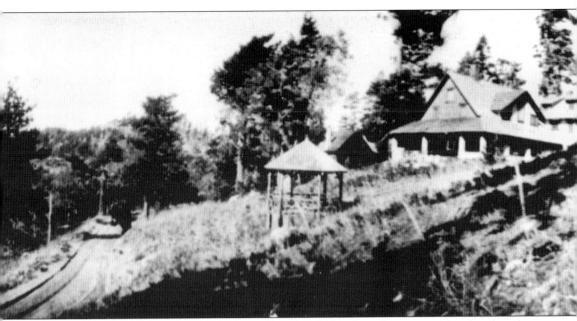

The Arrowhead Reservoir Company built a toll road in 1893 along the route of the abandoned Mormon Road to bring the materials, equipment, and cement needed to build the dam in Little Bear Meadow. After the road reached the crest, the road accessed the various campgrounds and resorts on its way to the meadow. This is the road as it passed the Squirrel Inn. (T.)

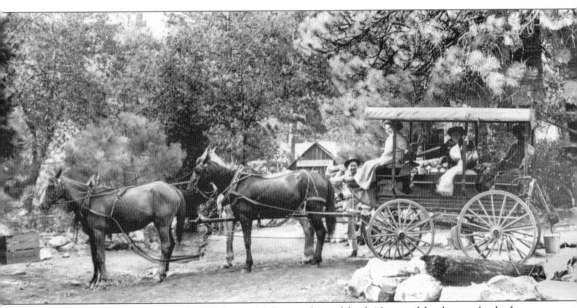

The Arrowhead Reservoir Toll Road was 14 feet wide and had 13 switchbacks to climb the steep grade near the crest. Despite the $2 toll, many campers used the stages to go up the Arrowhead Reservoir Toll Road to reach the primitive camps and new resorts. (T.)

Most people took the horse-drawn stage lines to get to the mountains. By 1896, the Cropley Stage Line was making three round trips per week, with stops at the Skyland Inn, Strawberry Flats, and Little Bear Meadow. (T.)

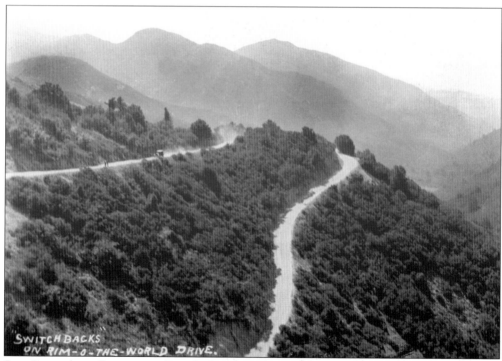

San Bernardino County purchased the Arrowhead Reservoir Toll Road, which ran up Waterman Canyon, from the Arrowhead Reservoir Company in 1905 and made it into a free road. Private wagon and stage traffic to the mountains doubled on the dirt road. (T.)

In 1909, the first automobiles were allowed to drive on the Arrowhead Road. It was very steep in places, with grades up to 25 percent. On some steep sections of the switchbacks, autos had to back up the hill so the gasoline would flow into the engines, as automobile fuel pumps were not yet invented. (T.)

In 1915, the Crest Highway was created by connecting the lumber roads together. This idea was suggested by Dr. John Baylis, who was the owner of Pinecrest Resort, located on the Crest Road between the Squirrel Inn and Little Bear Lake. (R.)

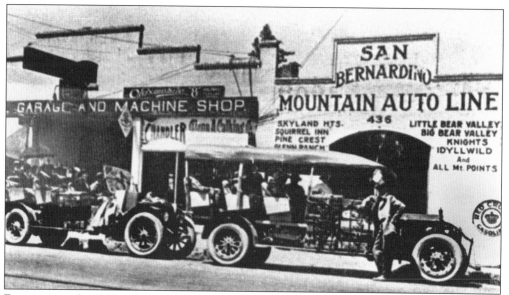

Former Arrowhead Reservoir workers Max and Perry Green started the Mountain Auto Stage service to the resorts, beginning in 1915. By 1921 they had 18 White trucks and stages that brought passengers and freight from the Pacific Electric Station, in San Bernardino, to the mountain resorts. (T.)

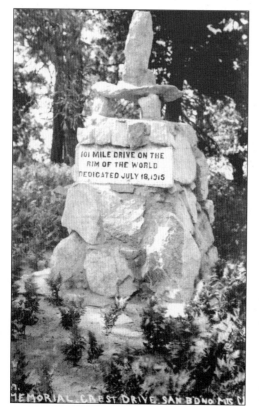

On July 17, 1915, the 101-mile "Rim of the World Road" was named and dedicated by Dr. Baylis on the road at a spot just west of present day Rim Forest. The roads had been re-graded for automotive use. Very few horse-drawn wagons or buggies were making the trip anymore. (R.)

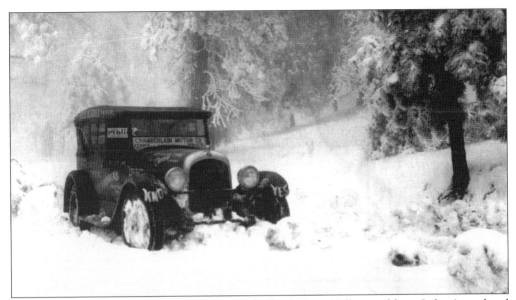

During the 1920s more visitors were visiting the Little Bear Valley, and later Lake Arrowhead and other mountain resorts, coming on stages and in private autos up the dusty, steep Rim Road. (T.)

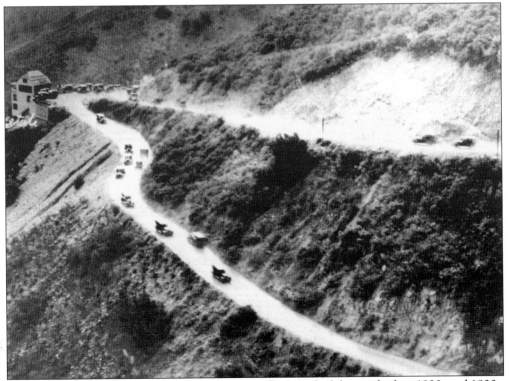

The Rim of the World "High Gear" Road was totally reworked during the late 1920s and 1930s, with new routes and lesser grades. This restaurant, located at Panorama Point, catered to the weary travelers. This is the same curve where the Caltrans Station was located, until the 2003 Old Fire burned it down. (R.)

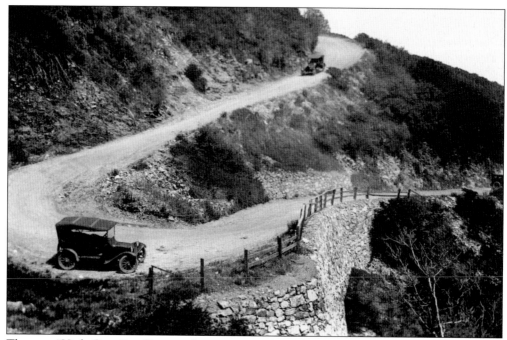

The new "High Gear Road" created a new route along the south face of the mountain, which eliminated the switchbacks and bypassed Crestline, creating "The Narrows" section of the road below Skyland. This is the section of roadway that washed out in December 2003. (T.)

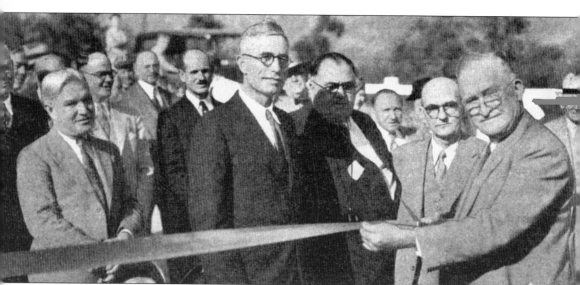

This October 22, 1933 picture shows State Highway Commissioner Frank A. Tetley Sr. cutting the ribbon on the High Gear Road bypass of Waterman Canyon. This 4.5-mile section of 24-foot-wide roadway (widened to four lanes in the 1960s) cost $350,000 to construct. (T.)

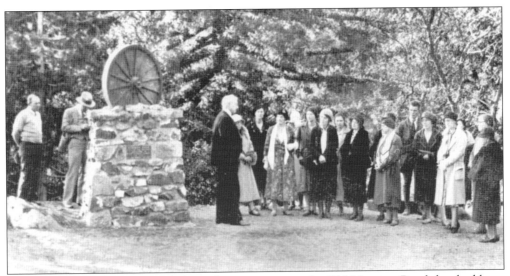

The Thursday Woman's Club dedicated a monument to the Old Mormon Road that had been built up Waterman Canyon, at the location where that road crossed the new Rim of the World Road, on November 10, 1932. (B.)

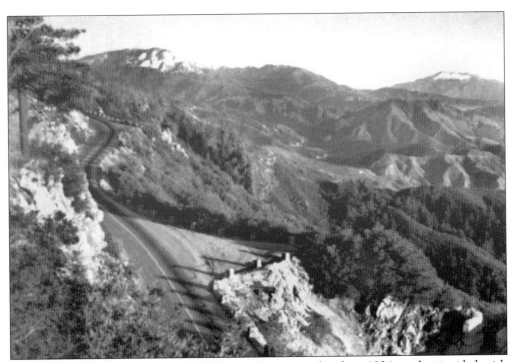

The newly paved, two-lane High Gear Road was completed in 1934, and coincided with improved automobiles. The turnouts along the road were small, but easy to pull into when only traveling the 15–20 miles per hour speed limit. This section of the Rim of the World Road is part of "The Narrows," below Skyland, and had spectacular views. (T.)

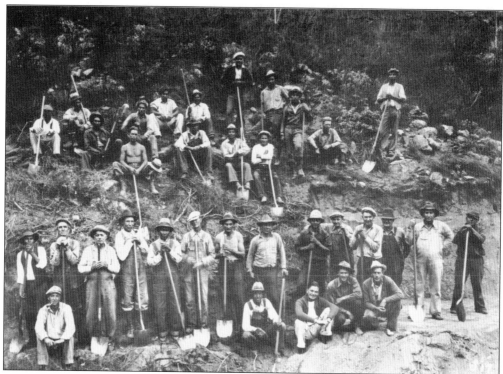

During the Depression not as many people used the new Rim of the World Road because of the cost of gasoline. The CCC built walls and road-edge barricades to prevent cars from going over the side. (R.)

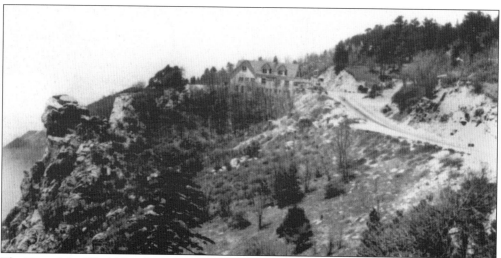

The Rim of the World Road saw more traffic after World War II, as the effects of gas rationing ended and people were once again interested in recreation. Sphinx Rock is shown on the left, at the eastern end of "The Narrows," as it passes Arrowhead Highlands, showing the clouds just below the Rim Road. (R.)

In 1956 a seven-mile section of the Rim of the World Highway was designated a freeway from the San Bernardino City limits to the Crestline Bridge, and was officially coined as California State Highway 18. The Auto Club has mapped the roadways, purchased road signs, and helped motorists since early motoring days. (R.)

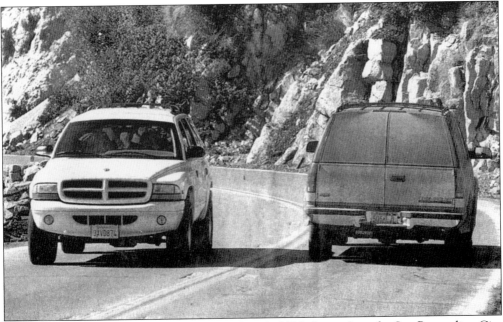

Designs were approved to widen the Rim of the World Highway, from the San Bernardino City limits to the Big Bear Dam, in the 1960s. Only the portion designated as a freeway, up to the Crestline Bridge, was ever completed because of the earthquake fault discovered while building that bridge in 1965. (T.)

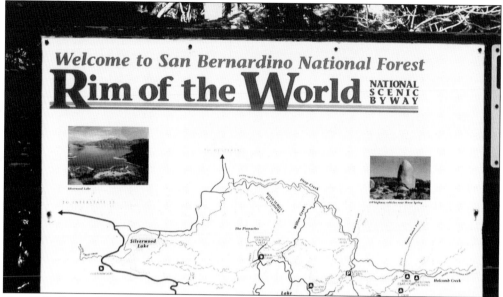

The U.S. Forest Service designated the Rim of the World Highway as a scenic byway on September 22, 1990. (T.)

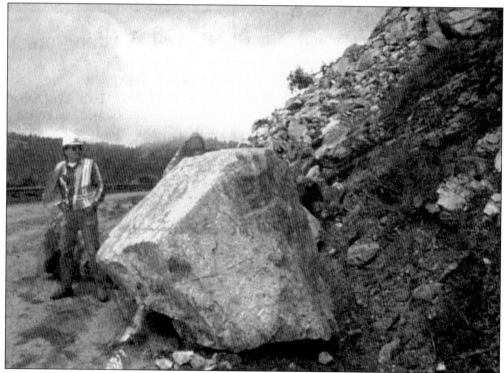

In 2000, the Narrows closed for 3 months due to a major hillside failure, which included a large rock falling on the road. When it was reopened, the community held a huge community "Rock Out" party and ribbon-cutting ceremony attended by thousands of residents. On December 25, 2003, a flood washed the roadway down the mountain slope in four places, closing the road for nine months (T.)

Six

CREATING THE IMAGE OF LAKE ARROWHEAD

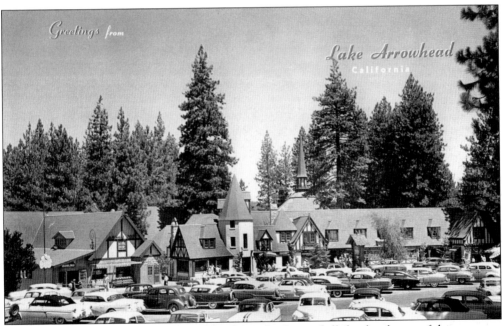

Creating an image for Lake Arrowhead has been the focus of all the developers of the area over the years. Because the green, forested, four-season mountain environment is so different from the surrounding parched, hot, desert valley floor below it, the mountains have been promoted as an escape for those living below. Lake Arrowhead has an image of cool relaxation in a luxurious, yet uncrowded natural setting, with many upscale shopping and recreation opportunities available. Lake Arrowhead Village was designed to promote and support tourism. (T.)

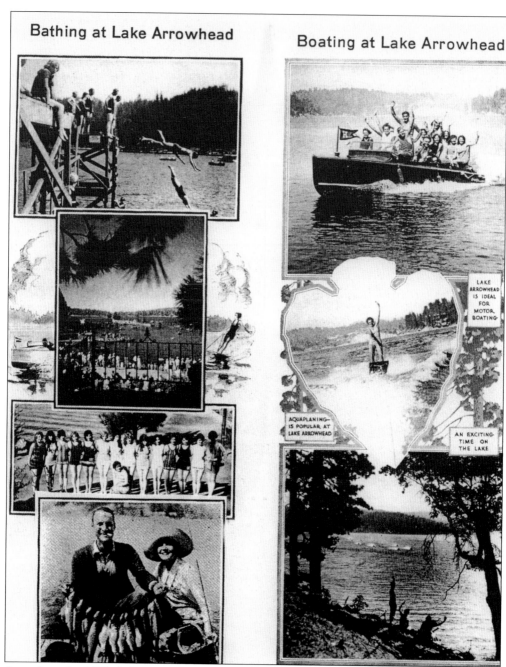

Bathing at Lake Arrowhead

Boating at Lake Arrowhead

LAKE ARROWHEAD IS IDEAL FOR MOTOR BOATING

AQUAPLANING IS POPULAR AT LAKE ARROWHEAD

AN EXCITING TIME ON THE LAKE

As early as the 1920s Lake Arrowhead promoted itself as the best resort in the San Bernardino Mountains. Brochures were printed exalting the area's assets and the variety of activities available for visitors. Summer water sports have always appealed to the California tourist. Lake Arrowhead had a beautiful lake on which to play. (R.)

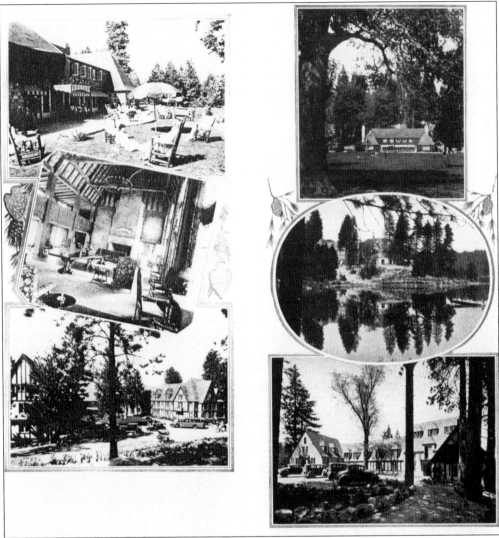

The luxury of the hotels was highly touted. The top photos are the front of the North Shore Tavern, on the north shore of the lake. The lower left photos show the Lake Arrowhead Lodge, which was on the eastern shore of Lake Arrowhead. The Village Inn, located near the village, is on the lower right. (R.)

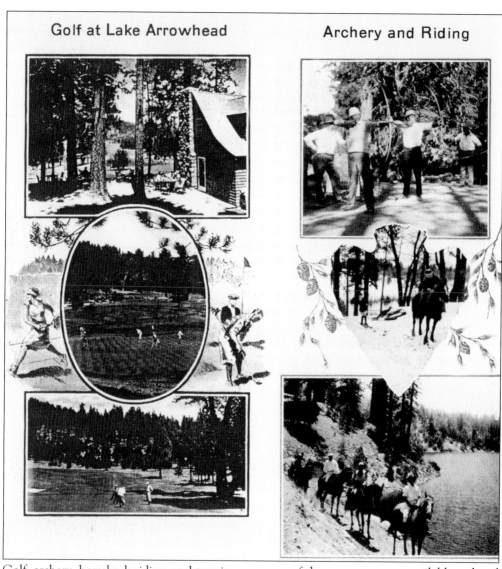

Golf, archery, horseback riding, and tennis were some of the summer sports available to hotel guests and vacationers at Lake Arrowhead in the 1920s. (R.)

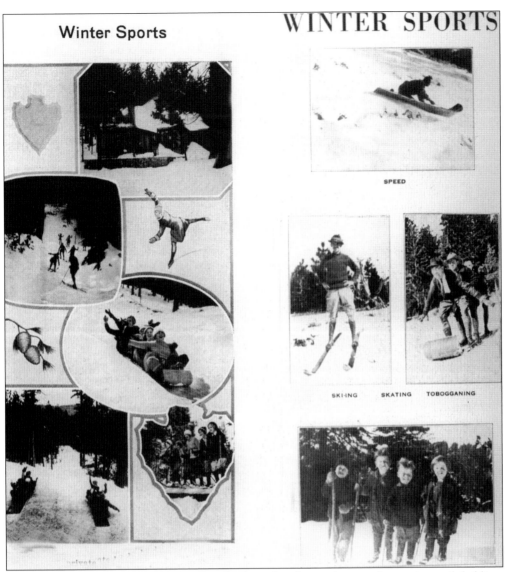

SPEED

SKIING SKATING TOBOGGANING

Winter sports that were promoted near Lake Arrowhead were skiing, tobogganing and sledding, ice-skating, and general snow play. Because the rest of Southern California does not get cold enough for snow, the idea of it was a novelty and was appealing to tourists. (R.)

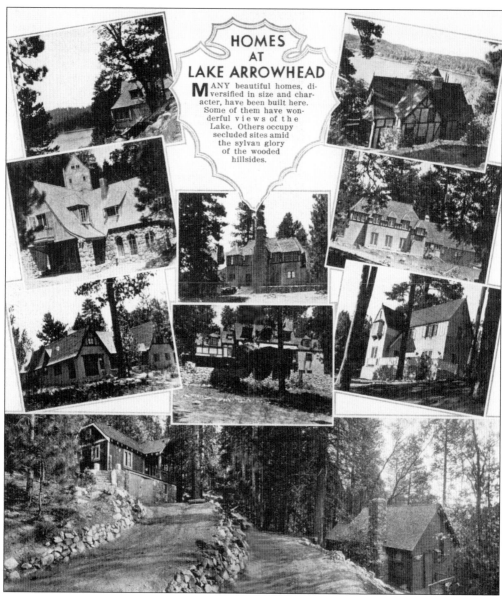

HOMES AT LAKE ARROWHEAD

MANY beautiful homes, diversified in size and character, have been built here. Some of them have wonderful views of the Lake. Others occupy secluded sites amid the sylvan glory of the wooded hillsides.

Real-estate sales have always been an integral part of the Lake Arrowhead development concept. Vacation homes, where a person could "get away from it all," were attractive to Americans during the 1920s. (R.)

Only property owners were allowed to launch boats on Lake Arrowhead, which was one of the reasons to purchase a vacation home in the Arrowhead Woods subdivision. (T.)

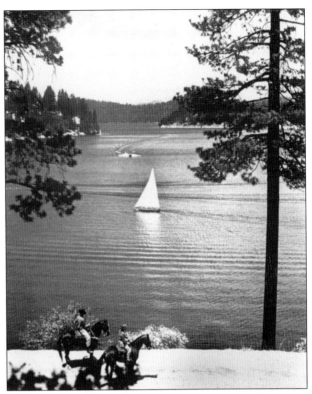

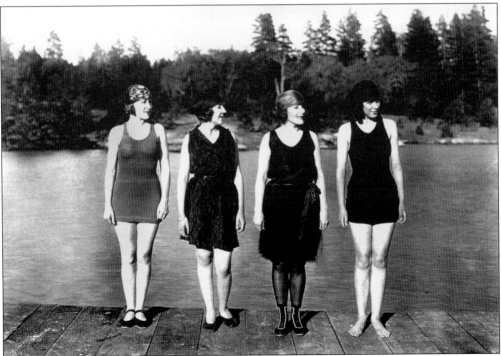

Bathing beauties have always been attracted to Lake Arrowhead. It was a great place "to be seen." (R.)

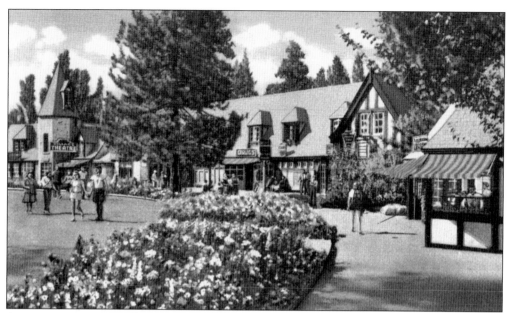

Artists were encouraged to come to Lake Arrowhead and capture its beauty on canvas. Numerous postcards were issued from these paintings. Postcards were a significant form of advertising and image building for Lake Arrowhead. (T.)

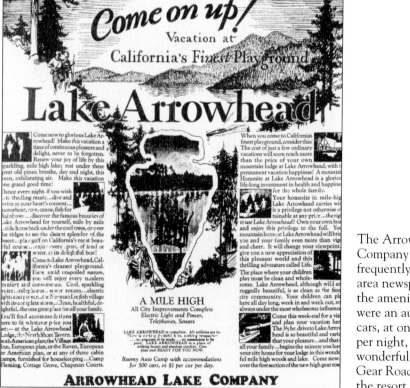

The Arrowhead Lake Company advertised frequently in Los Angeles area newspapers. Some of the amenities advertised were an auto camp for 500 cars, at only $1 per car, per night, and how wonderful the new High Gear Road made travel to the resort. (R.)

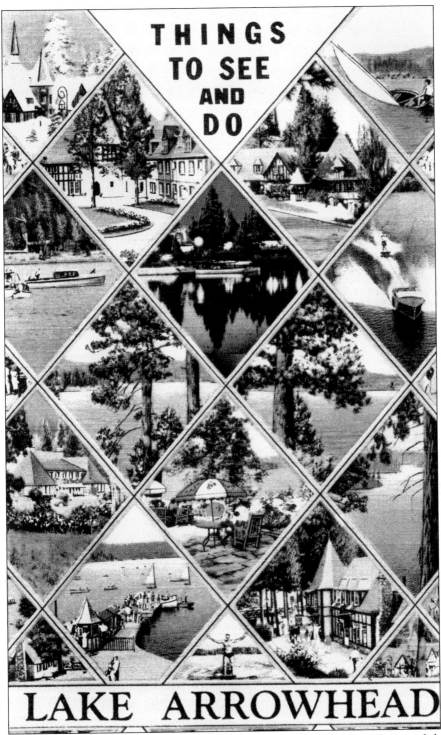

The back of this postcard from the late 1940s says, "Situated in the pine forests of the San Bernardino Mountains, 5,000 feet above sea level, only 80 miles from Los Angeles. Use the new High Gear Scenic State Highway all the way." (T.)

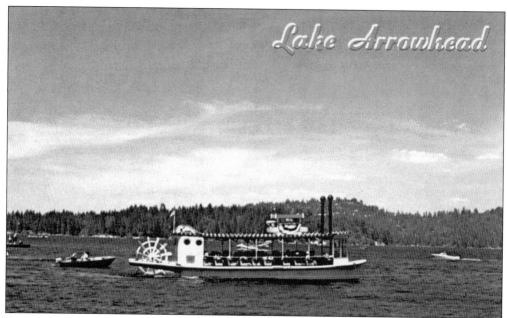

Tour boats have always offered excursions of Lake Arrowhead for visitors. The Arrowhead Queen tour points out the multimillion-dollar homes and former residences of many local celebrities and movie stars. Sailing into the coves and bays of the lake is one of the favorite activities of tourists visiting Lake Arrowhead, even today. (T.)

This postcard pointed out the mild, but white, winters at Lake Arrowhead, making it a true year-round resort without the bitter cold, and promoting the new sport of skiing. This is from the 1950s, but is reminiscent of the pinup girl pictures of World War II. (T.)

These quality homes, next to the country club, are now selling for nearly $1 million each. Their fabulous views of the fairways and trees, and close proximity to Mary Putnam Henck Middle School, make Grass Valley a desirable area of Lake Arrowhead to reside in. (T.)

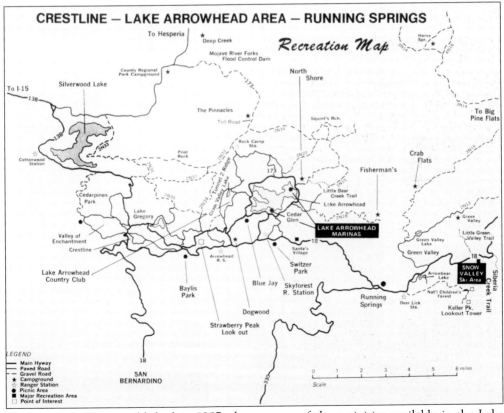

This recreation map, published in 1987, shows many of the activities available in the Lake Arrowhead area. (R.)

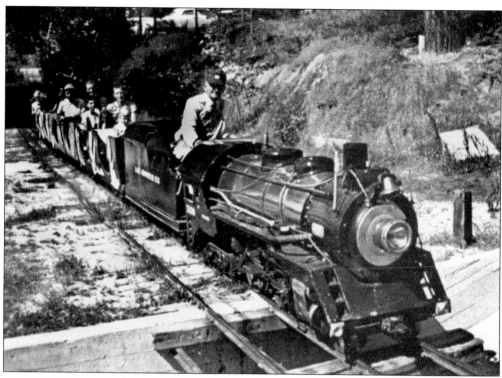

In the 1950s, Lake Arrowhead Village had shops, a penny arcade, a movie theater, a bowling alley, and a miniature steam-engine train to take tourists around the village and out to the shore. Lake Arrowhead tried to appeal to the upscale family as a luxury vacation destination. (R.)

The original lamp design used in the Old Lake Arrowhead Village gave a picturesque allure to the area. Here is a lamp, after a snowstorm, illustrating the appeal of a four-season resort, in California, less than 90 miles from Los Angeles and Hollywood. (R.)

Seven

THE MOVIES, THE STARS, AND LAKE ARROWHEAD

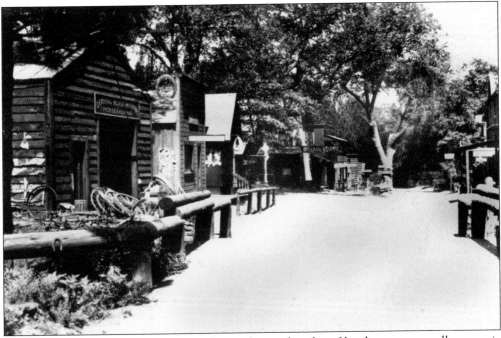

The San Bernardino Mountains were chosen during the silent film days as an excellent movie location because of the bright sunlight, excellent weather, and unspoiled wilderness. They were perfect for westerns, snow scenes, and mountains, plus they were close to Los Angeles, with resorts large enough to hold film crews. Whenever mountains, lakes, westerns, Indians, or modern romantic locales were considered, the San Bernardino Mountains were a preferred shooting destination. This picture shows the western village set built by the Leo D. Maloney (a western star) Production Company, where 18 silent movies were filmed in the mid-1920s. It was located in "Skyland Flats," approximately where Lake Drive in Crestline is today. (R.)

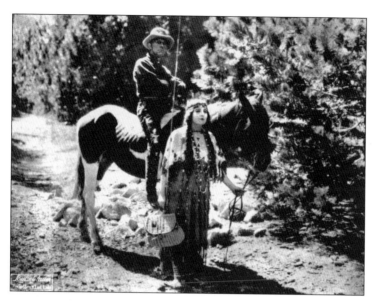

The Goddess of Lost Lake starred the sexy Louise Glaum as a college-educated, 75-percent Caucasian girl who decides to pretend she is a 100-percent Native-American princess when she visits her father's rustic cabin after college. This silent movie was shot in 1918 after Little Bear Lake had completely filled, and is believed to be the first movie shot at the finished lake. (C.)

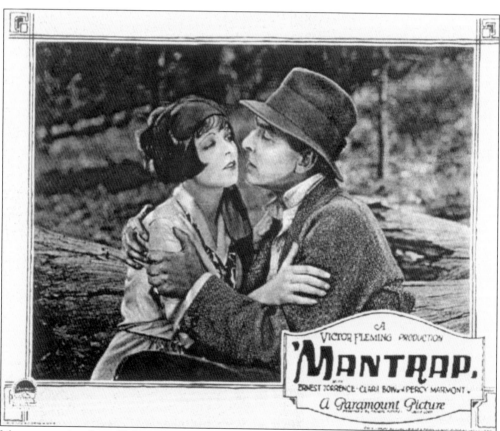

Mantrap, staring "it girl" Clara Bow, was filmed almost entirely at Lake Arrowhead in 1925. It used the lake in the storyline, and the production company built a fishing village on what later became known as Movie Point, now known as Point Hamiltair. (T.)

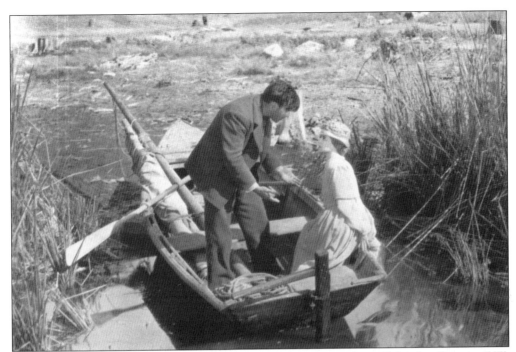

Considered by film historians as the first "talkie," *Sunrise* was directed by the German F.W. Murnau, who built an elaborate set, including a streetcar track in the forest (the streetcar was pushed by stagehands). *Sunrise* was nominated for four Academy Awards and won it three. Sound effects included cars honking, bells ringing, and a voice shouting during a traffic jam. (T.)

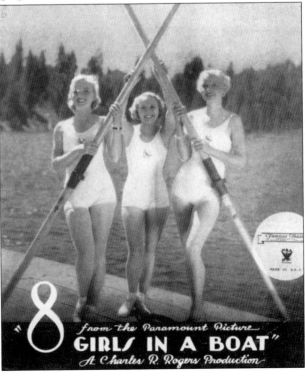

The 1930s and 1940s were considered the "Golden Age of Movies." Over 60 were filmed in and around Lake Arrowhead, including Canadian Mountie movies, and romantic comedies, and dramas. *Eight Girls in a Boat* was a Depression-era feel-good movie, made after a nationwide beauty contest. The winners received parts in the movie. (C.)

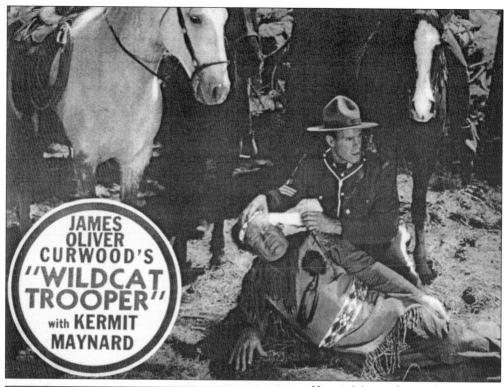

JAMES OLIVER CURWOOD'S "WILDCAT TROOPER" with KERMIT MAYNARD

Kermit Maynard starred in many Canadian Mountie movies including *Wildcat Trooper*, filmed at Lake Arrowhead, in 1935. He made nine movies in the San Bernardino Mountains from 1934 to 1937. *Wildcat Trooper* also featured Native American and Olympic champion Jim Thorpe. Both are shown in this picture. (C.)

Lake Arrowhead doubled for a Swiss lake in the 1935 musical *Three Smart Girls*, starring Deanna Durbin. Some scenes were filmed at Chateau des Fleurs, near the North Shore Tavern (now the UCLA Conference Center). (C.)

Another actress who made several movies in the Lake Arrowhead area was Shirley Temple. In 1933 when she was six years old, she made *Now and Forever* with Gary Cooper and Carole Lombard. It had scenes filmed, in 1933, on Lone Pine Island, located within Lake Arrowhead. The year before, she filmed *To the Last Man* at Cedar Lake near Big Bear. (T.)

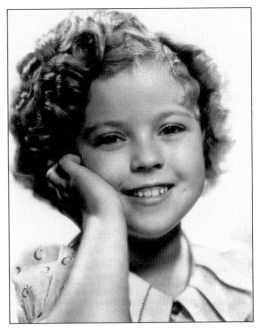

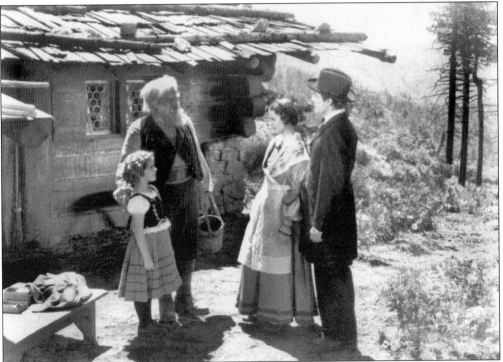

In 1937, the well-known movie *Heidi*, starring nine-year-old Shirley Temple, was filmed at Switzer Park, which doubled for the Swiss Alps. The actors stayed at the opulent Arrowhead Springs Hotel at the foot of the mountain, which was partially owned by Darryl Zanuck, the head of 20th Century Fox. Shirley filmed *The Blue Bird* in 1939 in Lake Arrowhead, and frequently visited the area. She was honored as grand marshall of the Blue Jay Parade in the 1950s. (C.)

Totem Pole Point got its name from the five tall totem poles placed there by Paramount Pictures when they filmed *Spawn of the North* in 1937. They hired local lumberman John Dexter to bring five tall logs to a peninsula in Blue Jay Bay, and the crew did the carving. Totem Pole Point was used for several more movies including *Outpost of the Mounties* in 1939. (Dick Mackey.)

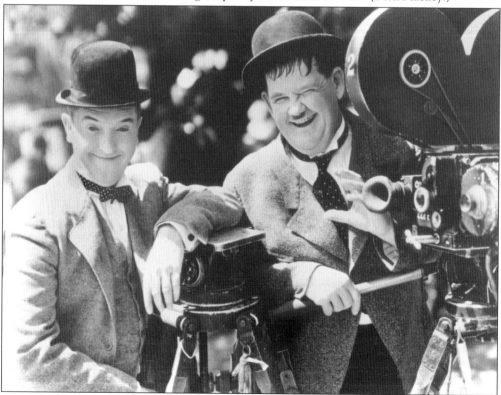

Swiss Miss, from Hall Roach Studios, was partially filmed in Lake Arrowhead in the fall of 1937. It starred Stan Laurel and Oliver Hardy, who in the storyline, go to Switzerland to sell mousetraps. Lake Arrowhead again doubled for the Alps in this musical comedy. (T.)

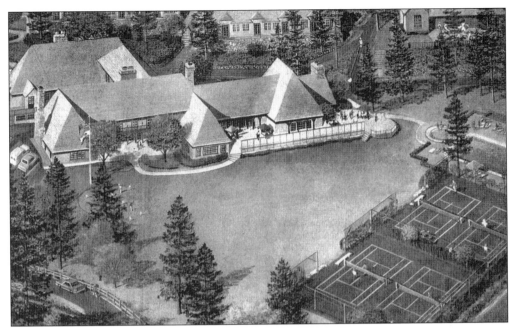

The 1940s saw a slowdown in movie production in the Lake Arrowhead area. However, of the ones made, many are considered classics, such as *Now, Voyager* starring Bette Davis, released in 1942. The scenes where Bette has her transformation were shot at the North Shore Tavern and the adjoining tennis courts. (T.)

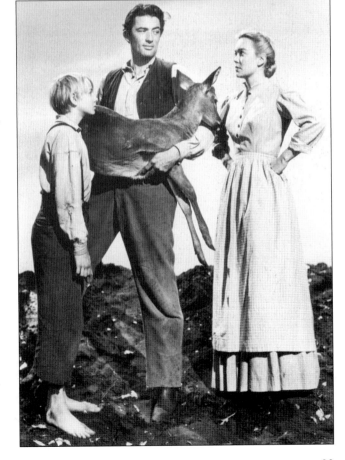

The Yearling, starring Gregory Peck, was filmed in Lake Arrowhead. June Lockhart, who already had a home there (purchased in 1939), also starred in the 1946 film. Many stars of the era had second homes at Lake Arrowhead during the years the Santa Anita Turf Club owned the resort area. (C.)

The 1954 remake of *Magnificent Obsession*, starring Rock Hudson, Jane Wyman, and Agnes Moorehead, was filmed entirely in Lake Arrowhead. The hospital scenes were shot at the newly completed Santa Anita Hospital (now Mountains Community Hospital). The original version of *Magnificent Obsession* (1935), with Irene Dunn and Robert Taylor, was also filmed in Lake Arrowhead. (T.)

The comedy duo of Jerry Lewis and Dean Martin shot *You're Never Too Young* in Lake Arrowhead. In one of the scenes of this 1955 comedy classic, they managed to get a motorboat stuck in the top of a pine tree. (C.)

94

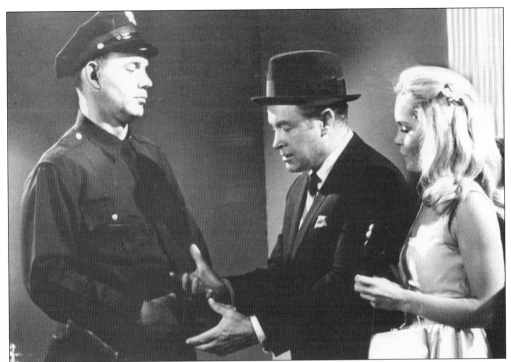

In the 1960s, Bob Hope filmed two movies in the Lake Arrowhead area. *Boy, Did I get a Wrong Number* also starred Phyllis Diller. This photograph is from *I'll Take Sweden*, which also starred Tuesday Weld and Frankie Avalon, and was directed by Frederick De Cordova in 1965. (C.)

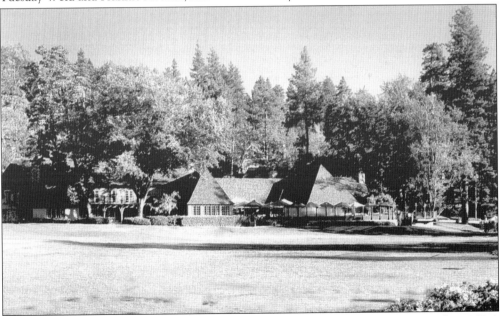

The American President, starring Michael Douglas, features a scene filmed at the UCLA Conference Center, where the president arrives at Camp David. The scene shows a helicopter landing on the lawn in front of the former North Shore Tavern and the president (Douglas) exiting. The scene was shot in March of 1995. (T.)

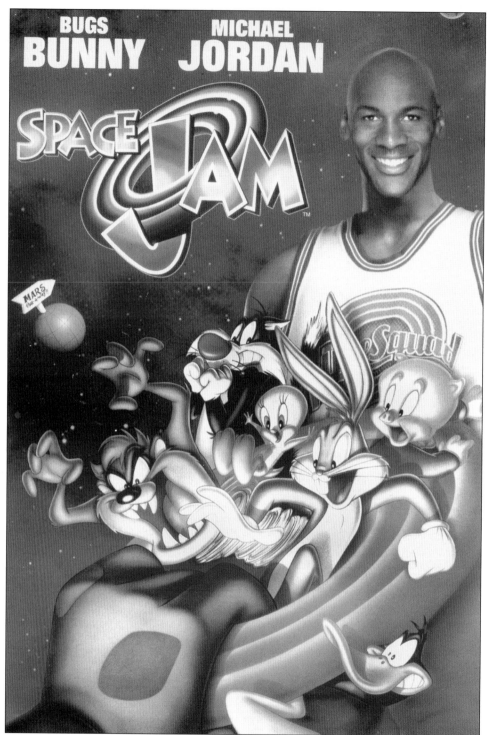

Michael Jordan, Bugs Bunny, and his Looney Tunes friends descended upon Lake Arrowhead in the movie *Space Jam*. in this 1997 animated and live action film, the Lake Arrowhead Country Club's golf course is torn up by Bugs as he tries to get basketball star Michael Jordan to help him. (T.)

Eight

AREAS SURROUNDING LAKE ARROWHEAD

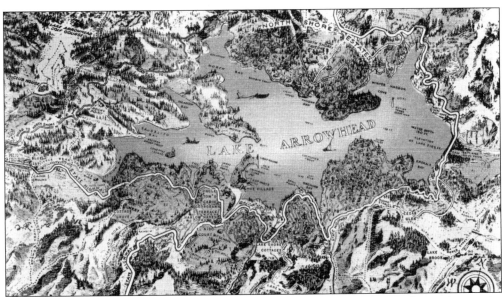

The communities and activities near Lake Arrowhead add to the mystique that makes up the Lake Arrowhead experience. The areas of Blue Jay, Twin Peaks, and Cedar Glen all were developed before The Arrowhead Lake Corporation purchased Little Bear Lake and changed its image from a rustic fishing lake to the upscale style of a French Norman village. Lake Arrowhead was described as 20 miles from San Bernardino, and nestled in a hidden valley between the pine-covered peaks. The sparkling blue water of the lake offer rest or play night or day, in a setting of incomparable charm. No wonder tourists flocked to the resort! (T.)

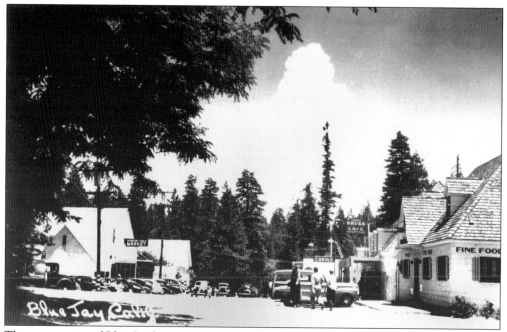

The community of Blue Jay began as William Coley's Steam Powered Sawmill on a dedicated 22-acre sawmill site. It was built where Pat's General Store is now located. Daley Canyon Road passed, next to the mill. (T.)

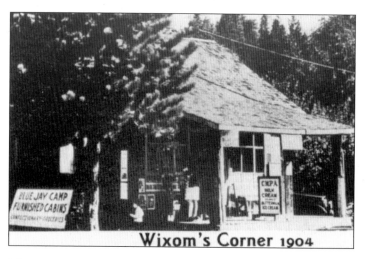

Wixom's Corner 1904

Art and Nora Wixom homesteaded 22 acres in present-day Blue Jay in 1904 and opened a store and had fishing cabins for those who wanted to test their angling skills in Little Bear Lake when it filled. In 1924, they changed the name from Wixom's Corner to Blue Jay, after the Stellar's Jays in the area. They also had stables for visitors who wanted to go horseback riding. (T.)

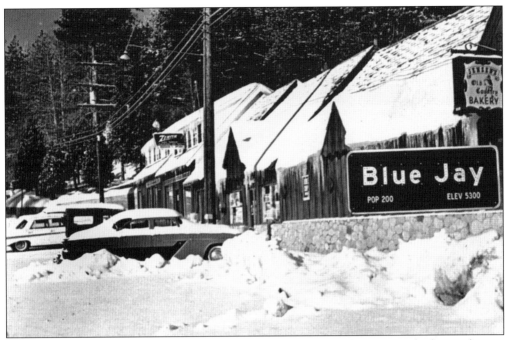

In 1934, Stoney De Ment bought the town of Blue Jay and built a store, which now houses Pat's General Store. In 1938, Einer Jensen opened the Mountain Ranch Market, located where Century 21 is now. Jensen's has since expanded to their larger location across the parking lot. (T.)

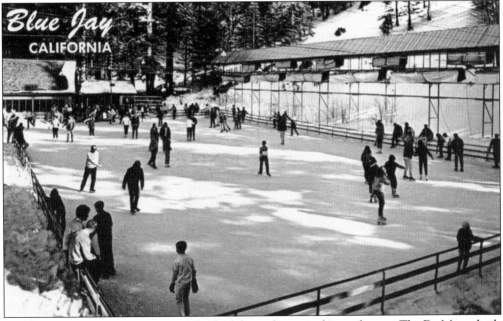

Harry Leuthold flooded an area next to the lake each winter for ice skating. The De Ments built the Blue Jay Ice Skating Rink in 1938, where the Rite Aid shopping center is today. It was considered one of the best year-round facilities in the country at the time. The Ice Castle Skating Center replaced the old rink in the 1980s. (T.)

Twin Peaks is located on the crest between Lake Arrowhead and the San Bernardino Valley. Twin Peaks (originally known as Alpine) was the business area that developed next to the locations of the Squirrel Inn and Dr. Baylis' Pinecrest Resort. (B.)

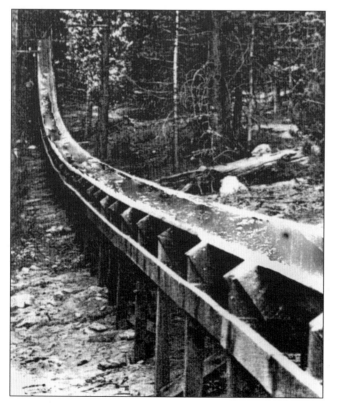

The Dexter family had three brothers who built a sawmill, a restaurant and hotel, and most of the other buildings in Twin Peaks. They also had a toboggan run, built by the family, for the community. (R.)

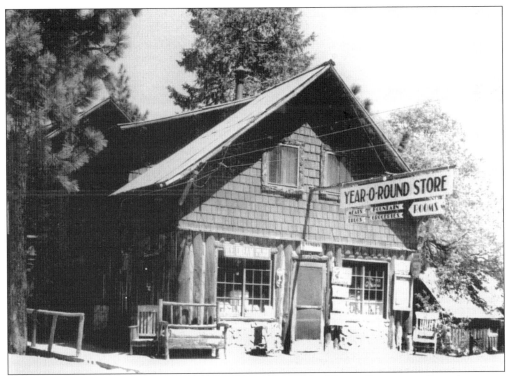

Twin Peaks was on the main road used by the Arrowhead Dam Company when they were bringing up the cement for the dam. This road, now known as Highway 189, became the town's main street and was used by the early stage lines. (R.)

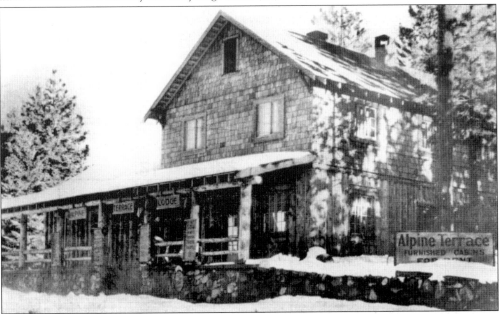

The Alpine Terrace, now known as The Antlers Inn, is in the center of Twin Peaks at the crest of the mountain. Built by Greg and Julia Dexter, it had a dance floor, a restaurant, and many cabins for rent. (R.)

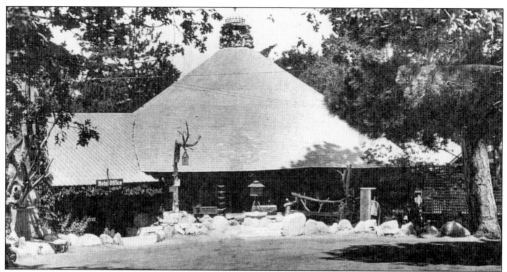

Twin Peaks also has the community baseball fields, the senior citizen center, and an elementary school located where the Strawberry Flats Campground was situated, from the 1920s to the 1950s. Pinecrest, started by Dr. Bayliss in 1906, still hosts hundreds of campers per week. (R.)

Twin Peaks is now known for housing the county building, which includes a courthouse, the sheriff's department, and other county offices for the mountain communities. Twin Peaks was chosen for its central location in the west end of the mountain communities. (A.)

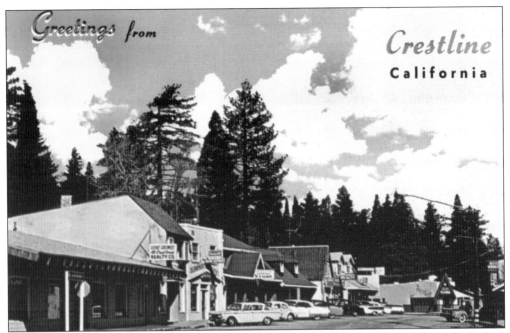

Crestline, the first mountain town passed on the way to Lake Arrowhead, was where the Incline Railroad had its upper terminus when bringing bags of cement up the mountain to build the Lake Arrowhead Dam in 1906. (T.)

Crestline's Lake Gregory, although not built until 1938, was one of the proposed lake locations in the original seven-lake project that included Lake Arrowhead in the 1890s. A tunnel was drilled, almost to the Huston Flats area, to move the water from Lake Arrowhead, on its way to San Bernardino before the massive water project was ruled illegal by the courts. (T.)

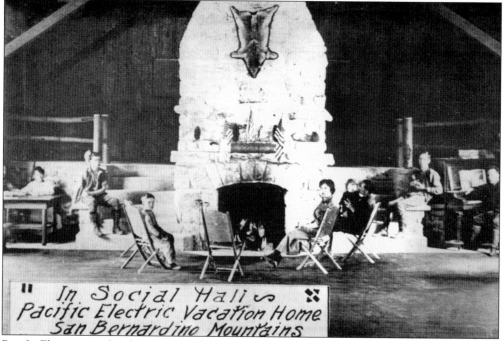

Pacific Electric was the electric trolley car line that connected the towns of Southern California before there were freeways. The town of Agua Fria was the town that developed near the location of Pacific Electric's "vacation home" for its employees, which opened in 1917. (R.)

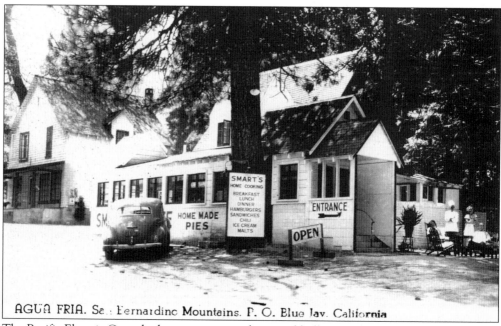

The Pacific Electric Camp had a swimming pool, a social hall, and dining hall. All that remains today is the social hall's chimney. Located on Daley Canyon Road, Agra Fria is between Blue Jay and the Lake Arrowhead Golf Course, and retains its unique individuality even today. (R.)

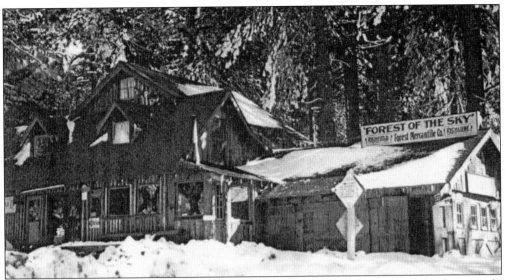

Originally called "Forest of the Sky," Skyforest is best known for Santa's Village theme park, which opened two weeks before Disneyland. There, children of all ages could visit Santa Claus at his home every day of the year. (H.)

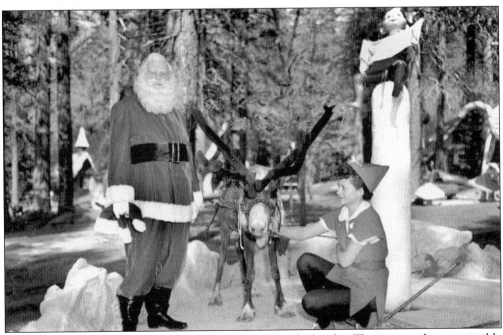

Skyforest was managed and developed by the Henck family. They were also responsible for starting the Lake Arrowhead Elementary School, running the Skyforest Post Office, Santa's Village, and reforesting the Heap's Peak area. They continue as members of the Lake Arrowhead Community. (H.)

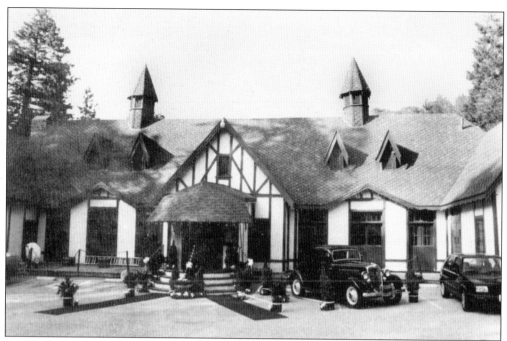

The Tudor House in Arrowhead Villas, originally known as Club Arrowhead of the Pines, had a reputation for hosting a speakeasy and clandestine gambling. Pure mountain water was used to made excellent moonshine. It is rumored Hollywood celebrities would fill up their spare "gas tanks" with the illegal brew from the 500-gallon still. (R.)

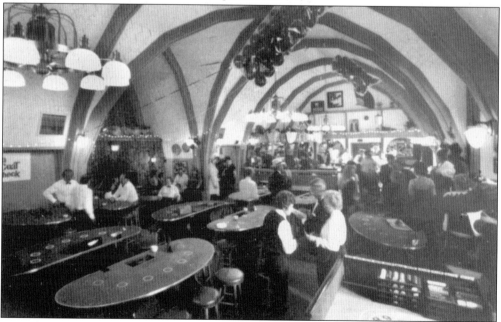

Arrowhead Villas also had a reputation; the same lots were sold and resold to different people, without deeds ever actually recorded. They may not have been the most honest property developers (they were reportedly friends of mobster Bugsy Siegel) and may have been in it for a "fast buck." (R.)

Sawmill owner John Suverkrup began selling lots for a camping/fishing resort in the early 1910s. He sold mountain lots large enough for a camping tent, near the dam. This area next to the dam is now known as Cedar Glen. This photo of the Cedar Glen Cafe is from 1948. (T.)

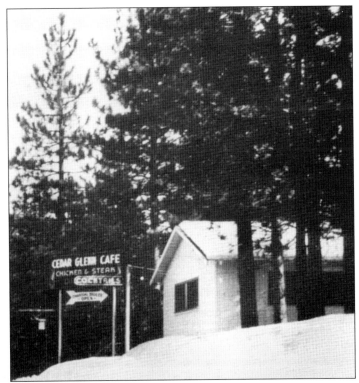

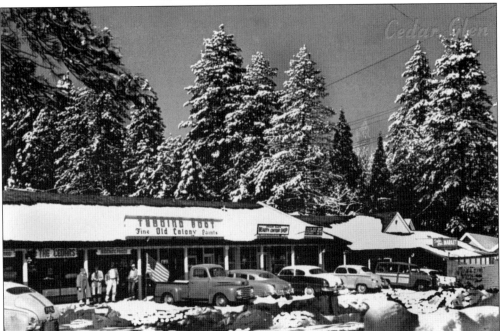

Cedar Glen Village is located where the workers camped during the 1890s while building the dam for Little Bear Lake (aka Lake Arrowhead). Cedar Glen Village now houses antique shops, restaurants, a hardware store, and a market. Cedar Glen Village today still resembles this photo from 1956. (R.)

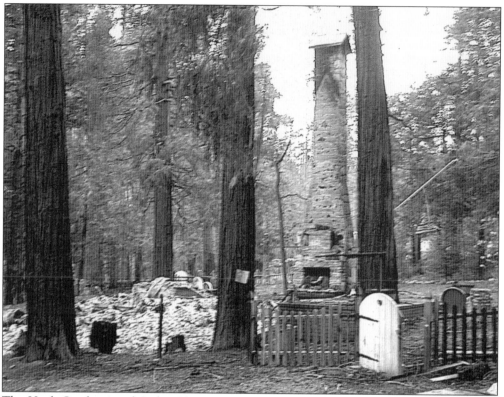

The Hook Creek area of Cedar Glen was severely affected when the 2003 Old Fire jumped Highway 18 and burned over 300 homes. It will be years (if ever) before the homes can be rebuilt because 2004 building requirements are stricter than in the 1920s, when the area was originally subdivided. (A.)

Rim Forest is located on both sides of Highway 18, just west of the Daley Canyon Road junction and Rim of the World High School. The western end of the business district of Rim Forest was burned in the Old Fire. Rim Forest has many services used by the entire mountain area, including Rim Lumber, Edison Company, Cottage Restaurant, Rim Park District, Fire Lookout Tower, Elks Club, the animal hospital, and the fire department. (T.)

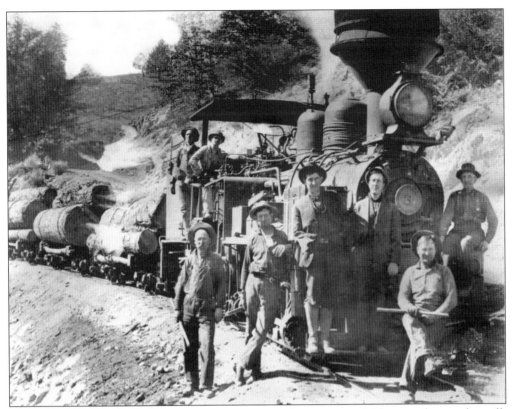

The Brookings Lumber Mill set up a narrow-gauge rail system to quickly move logs to the mill. Between 1899 and 1912, the Brookings Mill clear-cut over 6,000 acres of land. They then moved to Brookings, Oregon, leaving the future Running Springs area scarred. (T.)

City Creek Road (now Highway 330) went past the Fredalba Resort—owned by the Smiley Brothers of Redlands—to the Running Springs area, where it connected with the Rim Road. City Creek Road offered an eastern approach to Lake Arrowhead, from the Highland and Redlands side of the San Bernardino Valley. (R.)

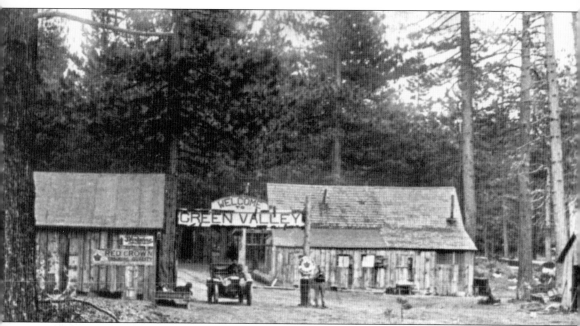

The original route of Rim of the World Road to Big Bear went through Green Valley, where the Tibbits family ran the tollhouse and the hotel. The hotel was necessary, as it was a two-day journey in the 1920s to get to Big Bear from the San Bernardino Valley. This was the beginning of the town of Green Valley Lake. (R.)

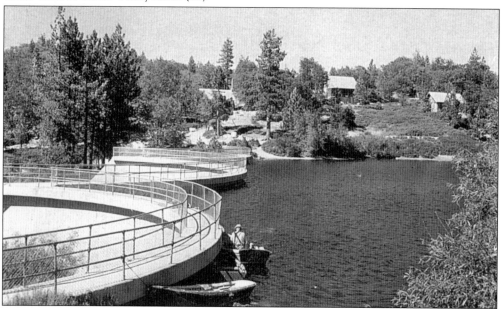

Rim of the World Road was rerouted from Green Valley in 1923 to a new road along the southern face of the mountain, going eastward to Big Bear. The amount of traffic traveling through Green Valley quickly decreased. To encourage new tourism, local resident and promoter "Green Valley Mac," as Harry McMullen was known, envisioned a fishing retreat with a lake. The multiple arch dam seen here was completed in 1926. As Green Valley Mac declared, "The fishing is fabulous!"

Nine

LAKE ARROWHEAD TODAY

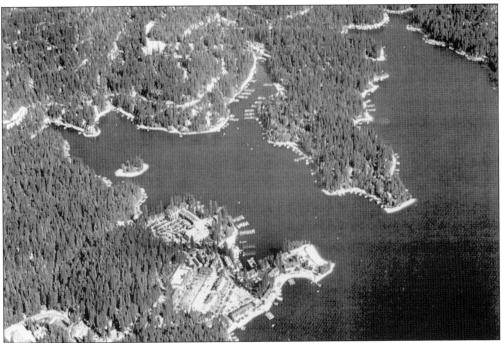

Lake Arrowhead is a tourist destination with a supportive small-town community. Some residents commute down the mountain to work while others work on the mountain supporting the resort and vacation industry. This aerial view of western Lake Arrowhead shows the village, the yacht club, and the Lake Arrowhead Resort on the peninsula. The original schoolhouse, now Fire Station No. 91, and one of the original hotels (the Raven) to the lower left. Looking clockwise from the village are Lone Pine Island, Blue Jay Bay, Rainbow Point, Meadow Bay, Point Hamiltair (formerly Movie Point), and North Bay, with Tavern Bay and the former North Shore Tavern, now the UCLA Conference Center, in the upper right. Lake Arrowhead's dam, the outlet tower, and the eastern part of the lake is out of the shot to the right. (R.)

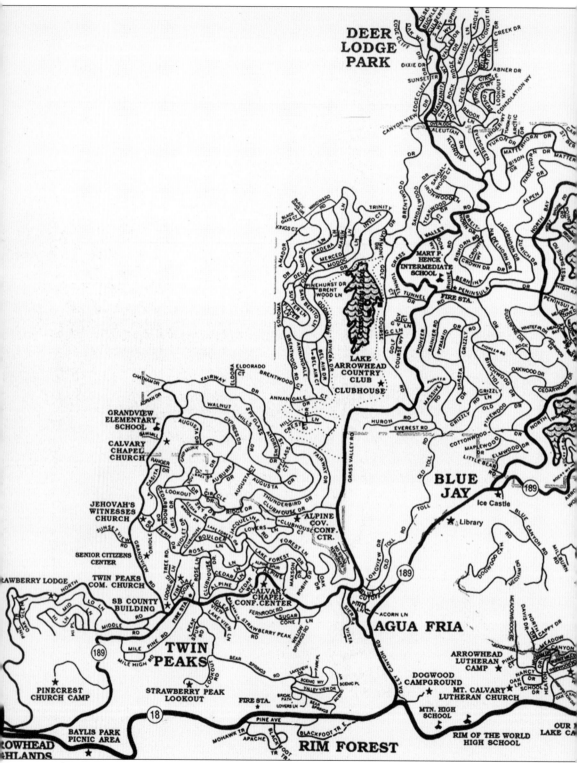

This is map of Lake Arrowhead shows schools, churches, camps, and other important places.

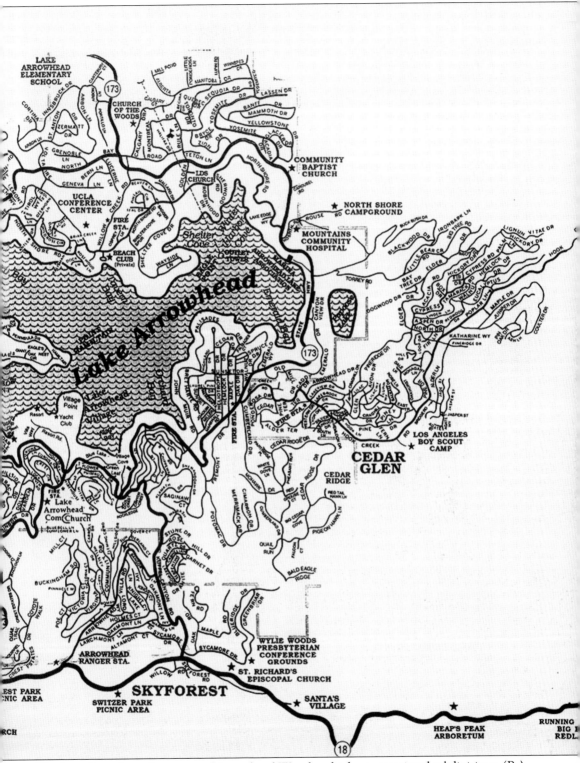

The long lines show the extent of Arrowhead Woods, which are associated subdivisions. (R.)

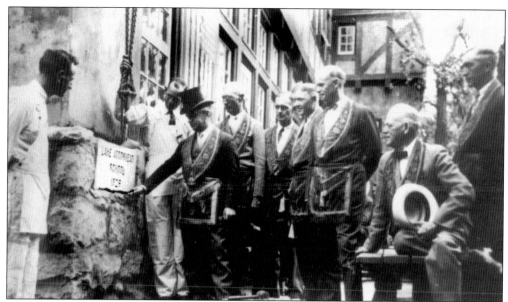

The first Lake Arrowhead school was created when former teacher Mary Putnam Henck of Skyforest organized parents into forming a school district for their children and passed a bond to build this school in 1924, now Fire Station No. 91. Here is the laying of the cornerstone. (Rim of the World Masonic Lodge 711.)

The Lake Arrowhead School joined with the Crest Forest School and Running Springs School to form the Rim of the World Unified School District in 1954. Lake Arrowhead Elementary is now located north of the lake, on Golden Rule Road. (T.)

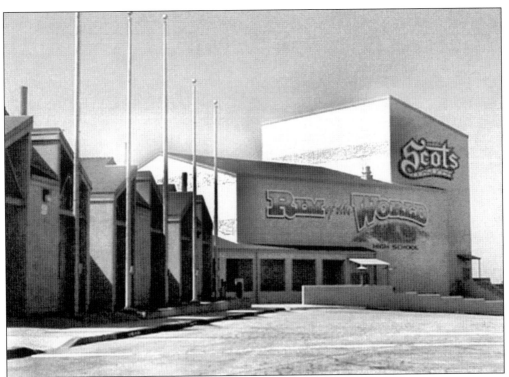

In 1956 Rim School District built Rim of the World High School next door to the elementary school. Rim High's first graduating class consisted of 41 students. Now, approximately 450 students graduate each year. Over 90 percent of Rim's students attend higher education after leaving high school. (T.)

The largest single employer on the mountain is the Rim of the World School District, with 830 employees serving 5,750 students in grades K through 12. The district has four elementary schools, one middle school, an alternative school, and a high school. Their motto is "Rim schools . . . above all others." (T.)

U.S. ski-jump champion John Elvrum was brought to the Lake Arrowhead area by the Lake Arrowhead Village Corporation to promote recreational skiing in 1934. He developed a hillside near Running Springs into Snow Valley in 1941. Lake Arrowhead promoted the area as part of their recreational facilities (R.)

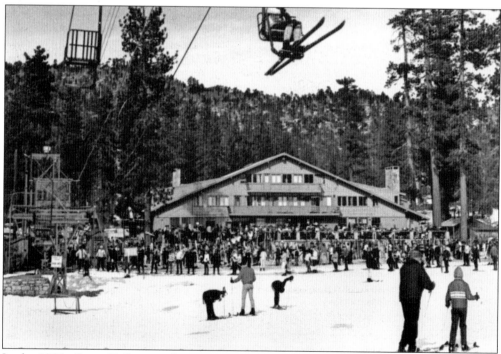

In the 1950s, Snow Valley was the most popular ski resort in the San Bernardino Mountains, with 10 rope tows, the first double chairlift, a natural outdoor skating rink, and a ski lodge. The ski runs were up to a mile in length. Snow Valley had rental equipment and instructors for beginners. (R.)

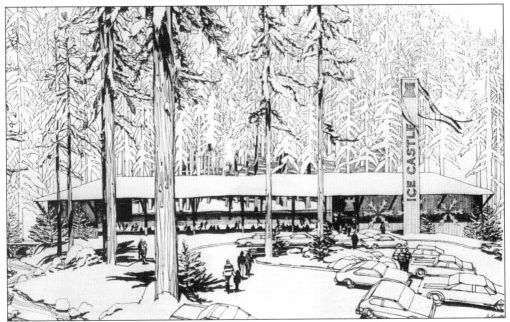

Blue Jay has had an ice-skating rink since 1938. In the 1980s, the Ice Castle Skating Center opened to the public and taught a whole generation of mountain children and tourists how to ice skate and play hockey. (R.)

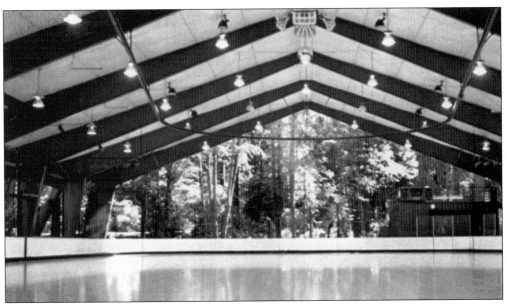

The Ice Castle International Training Center has trained Olympic Medalists such as Michelle Kwan, Sasha Cohen, and Nicole Bobek, and is now owned by Olympic skater and six-time Australian national champion Anthony Liu. The training center has been open for limited public skating sessions since the roof of their public rink collapsed under a heavy snow load in February 2001. (L.)

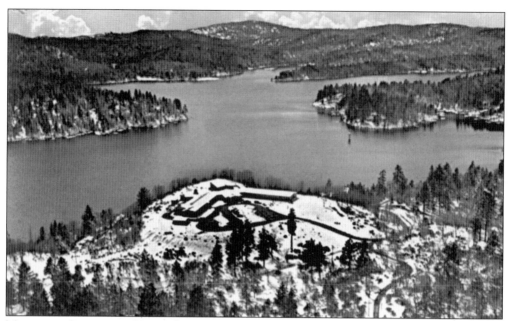

Mountains Community Hospital was opened in 1951 by the Sisters of St. Joseph of Orange. Much of their early business came from toboggan riders who crashed at Snow Valley. The hospital now offers a long-term care unit, as well as emergency services. Numerous scenes from *Magnificent Obsession* (1954) were filmed there. (R.)

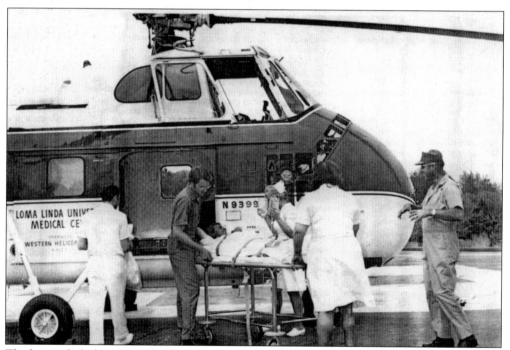

The hospital's helicopter pad offers quick transportation for serious cases that need to be moved to another hospital. The hospital offers complete medical services to the entire mountain community. (R.)

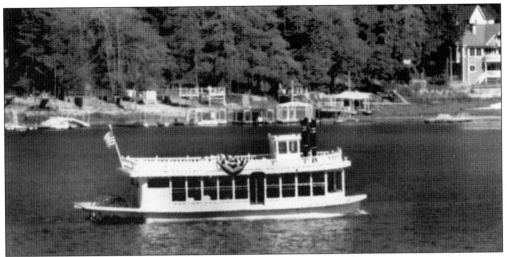

The *Lake Arrowhead Queen* offers hourly tours of Lake Arrowhead year-round. From the Queen, the locations of movie stars homes are pointed out and the history of the area is shared. No first-time visit to Lake Arrowhead is complete without a cruise on the *Queen*. (R.)

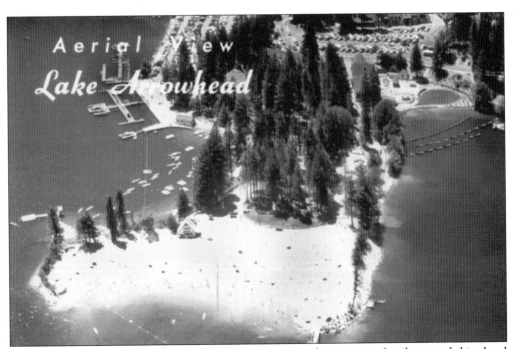

The McKenzie Water Ski School is the oldest continuously operating family-owned ski school in the country. It is located on the peninsula next to Lake Arrowhead Village. Open only during the summer season, the McKenzies used to work during the winter season at Snow Valley in the 1950s and 1960s. (R.)

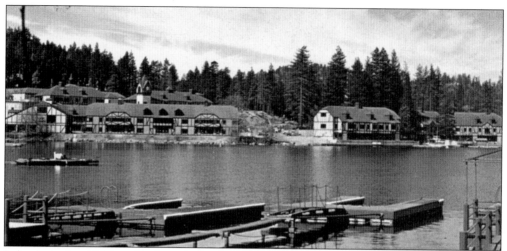

Lake Arrowhead Village has boat docks available for customers of McDonalds and the Bank of America, as well as the other stores. Sailing or speed boating across the lake is a shortcut to Lake Arrowhead Village for residents of the Arrowhead Woods. (R.)

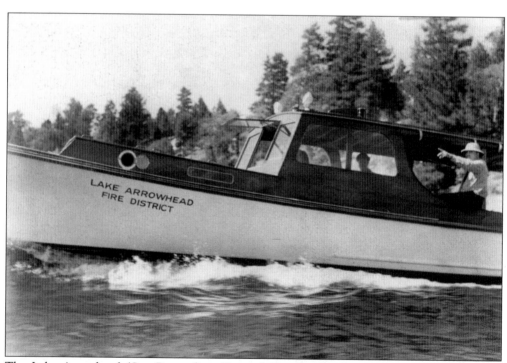

The Lake Arrowhead (San Bernardino County) Fire District has four stations in the Lake Arrowhead area. The fireboat can assist during lakefront home fires by pumping lake water onto a fire and rescuing stranded passengers on burning boats. (R.)

Lake Arrowhead's first golf course, with nine holes, was constructed in 1924. The golf course is situated next to Grass Valley Lake and was built in a pasture, where the cattle had grazed during the construction of Lake Arrowhead. In the original seven-lake plan, the whole golf course would now be underwater. (R.)

Between 1960 and 1967, the Lake Arrowhead Development Corp., under the direction of Jules Berman, developed a luxurious 18-hole golf course and country club. (R.)

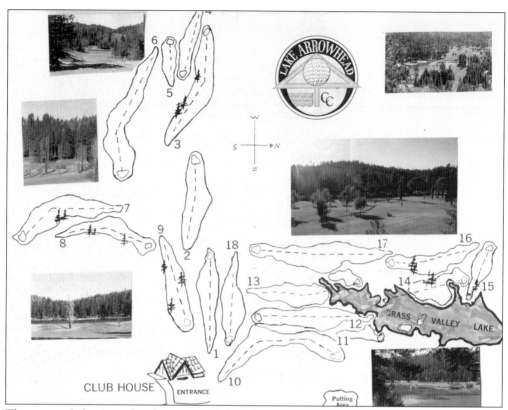

The private Lake Arrowhead Country Club and Golf Course hosts charity events and has been used as a location for movies, harking back to the Lake Arrowhead days of old. (R.)

The Arboretum, located on Highway 18 near Heap's Peak began as a school project in 1928. It was restored in the 1980s by George Heseman, a retired forest worker who wanted a publicly accessible area to explore the native vegetation of the San Bernardino National Forest. (R.)

The one-mile, easy-walking path through the Arboretum has trees that are labeled and natural plants demonstrating the diversity of the forest. This is a showplace for nature lovers. Teacher Mary Putnam Henck (at left) used Arbor Day as a lesson and project for her classes. They spent several years replanting this area of the forest that was burned by a fire in 1922. (H.)

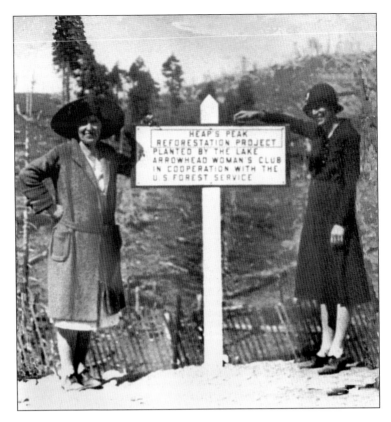

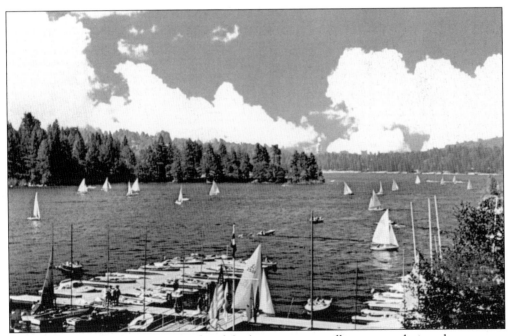

Lake Arrowhead has a private yacht club that sponsors sailboat races during the summer. Water-skiing is another popular lake activity. (R.)

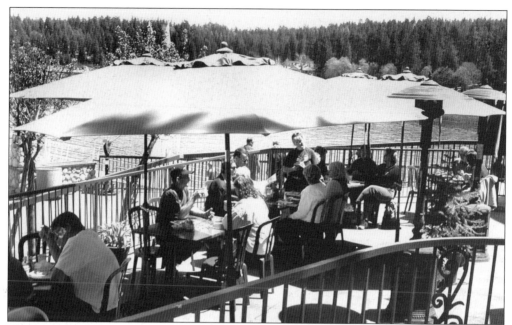

Lake Arrowhead's year-round population is around 11,000, but on weekends and summers it easily triples, as owners of second homes and visitors come to enjoy the mountain resort's activities. The mild weather attracts millions of visitors every year. (R.)

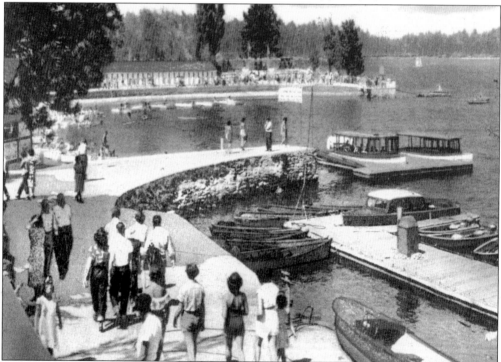

The prolonged drought in Southern California at the turn of the 21st century has affected Lake Arrowhead by dropping the lake level 25 feet. This dock area is now a 100-foot-wide beach where the chamber of commerce has staged concerts, movies, and other community events (T.)

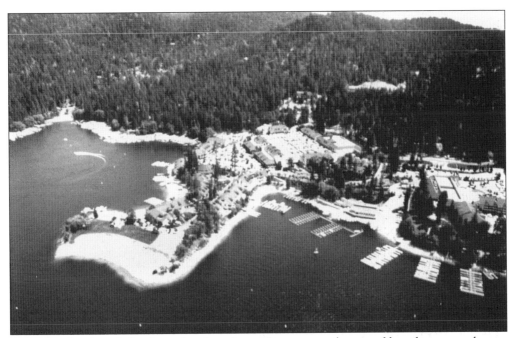

The water levels in Lake Arrowhead are lower due to several years of less-than-normal snow and rain, so the docks are farther away from the lakefront homes, but that means more shore for volleyball games and sunbathing! (R.)

In October 2003, the Old Fire burned over 300 homes around the community's perimeter along the Rim Highway and in the Hook Creek area of Cedar Glen during the biggest week of firestorms in California's history. Rebuilding is starting with a positive attitude, as people continue to flock to the area. (T.)

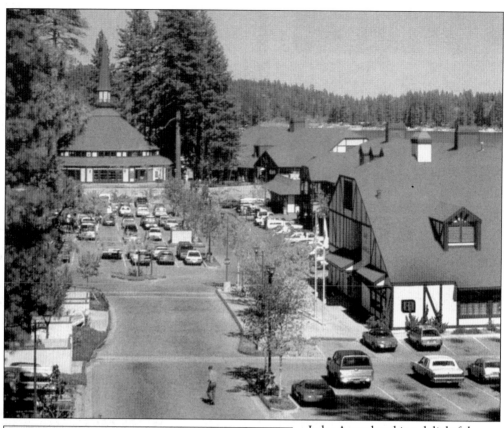

Lake Arrowhead is a delightful place for a vacation or as a place to live. The citizens are proud of their history and look forward to their future. The pavilion from the original village symbolizes this respect for the past, while looking upward and forward! (R.)

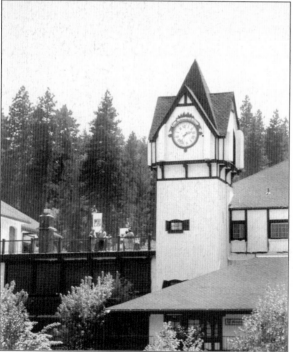

Lake Arrowhead Village sponsors weekly events for the thousands of tourists and locals that visit there. The stage showcases entertainment bridging the spectrum of musical tastes. The clock tower can be seen from all points in the village and from the lake. (R.)

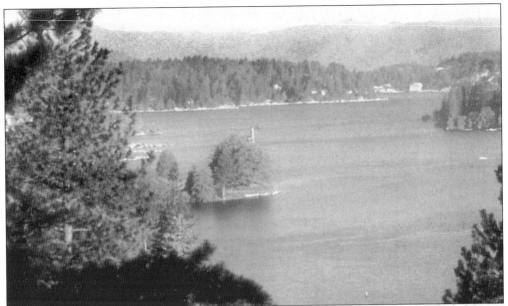

The variety of places to eat, from casual to elegant, serve a wide demographic of visitors and residents. Lake Arrowhead is famous world wide, and tour busses bring people from all countries of the world to see the beautiful lake that has been featured in so many movies, and radiates elegance. (L.)

Residents of Lake Arrowhead enjoy boating and being with friends. This boat is transporting residents on the annual home tour. Each year, one home is only assessable by water. They welcome you to come visit Lake Arrowhead, a forest paradise, less than two hours from Los Angeles. (L.)

"Goodbye from Lake Arrowhead, y'all come and visit us real soon!" The friendly residents of Lake Arrowhead in the San Bernardino Mountains of Southern California do hope you will visit often.